Momma

I Love You!

Thomas Kelley Davison

2018

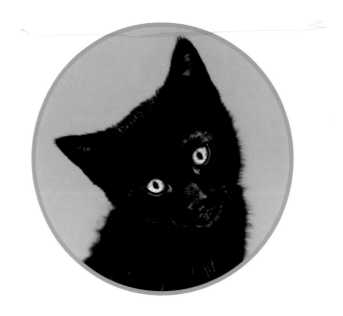

"Those who don't believe in the positive magic of black cats will never enjoy their charms."
–Layla Morgan Wilde

Advance Praise

"There's something about a black cat that sets my soul on fire—ebony magic dipped in starlight! That they are often passed by in shelters is a great loss to families looking to bring home a loving feline companion. Thank you, Layla, for sharing their stories and images so that others can see their beauty. May all black cats find forever homes soon."

–Christine Davis, award-winning author and illustrator of **For Every Cat An Angel, Forever Paws** and other inspirational titles from Light-Hearted Press, bring comfort to readers all over the world.

"Congratulations to Layla for helping redress centuries of discrimination, not to mention Pope Gregory IX's infamous Papal Bull. Thanks for all you do in the world on behalf of other sentient beings!"

–David Michie, author of **The Dalai Lama's Cat series** and **The Queen's Corgi.**

BLACK CATS
Tell All

True Tales
and
Inspiring
Images

Edited by
Layla Morgan Wilde

Published by
Cat Wisdom 101 Press

First published in the U.S. in 2017 by Cat Wisdom 101 Press
460 Ridge Rd. Hartsdale, N.Y. 10530
www.catwisdom101.com

This book was conceived, produced and published by Layla Morgan Wilde. Cover design by Michael Rohani. Cover image by Jay Bondelli. Back cover images by Monica Sisson (left) and Micha Lema (right). Interior design by Jennifer M. Markley.

Library of Congress Control Number: 2017910676
Wilde, Layla Morgan
Black Cats Tell All: True Tales & Inspiring Images
1st Edition.
1. Anthology of black cat stories.
2. Cat photography.
3. Cat pop culture.

ISBN:978-0-9980591-9-8
e-ISBN:978-0-9980591-8-1

*This project is dedicated to all black cat lovers,
especially those who have adopted a black cat and
know cat love is color blind.*

*To Merlin, my feline muse of 21 years who died
before he could hold it in his paws.
Merlin passed the torch of love and
compassion to Clyde, who puts the
special in special needs, black cat style.*

Introduction

from the editor and publisher

the first collection of positive black cat stories and amazing photos to essentially rebrand black cats

Over the years, I've worked with many cats at shelters and time and again seen amazing black cats overlooked simply because of the color of their fur. The shelter adoption stats tell a shocking truth: black cats are half as likely to be adopted as cats of other colors. I took it as a call to action.

I'm a cat expert, cat advocate and founder of Cat Wisdom 101, where we've enlightened and entertained cat lovers since 2011. Our motto is to change the lives of cats, one purr at a time. To change the lives of black cats, a new and innovative approach was needed. In a lightbulb moment, I came up with the idea for Black Cats Tell All, the first collection of positive black cat stories and amazing photos to essentially rebrand black cats as being just as adorable and adoptable as all other cats.

It's not only the first book of positive black cat stories. It's the first book to combine stories with a rich array of images of black cats from all over the world in order to celebrate the joys of living with black cats. The stories and light-hearted profiles are narrated by the fearless felines (and sometimes their owners) who feel it's time to tell the world the truth. These amazing black cats share nothing in common except the color of their fur and a yen to pen their stories. They reveal how wildly entertaining and fabulous black cats can be. Some stories will make you laugh out loud, while others will make you cry. All will make you think about black cats with joy and reverence.

Our goal is to change perceptions about black cats, one story, one photo at a time. One day, when someone Googles "black cat stories," Black Cats Tell All will pop up and not just the Edgar Allan Poe horror story. And one day, someone deciding to adopt the cute tabby at the shelter may think twice and consider the sleek house panther waiting in the corner.

Change doesn't happen in a vacuum. It takes a village to raise awareness, and this personal initiative, Black Cats Tell All, created a tribe of like-minded black cat lovers, the people who submitted material for this book. Many responded to my online call for submissions. Others, I reached out to one-by-one, scouting cats on Instagram and Facebook. There are no stock images. The selection process involved hundreds of messages, curating thousands of images and many sleepless nights. As you can imagine, it was no easy task to winnow a massive body of submissions into something you can hold in your hands. The process involved trusting skill with intuition and allowing it to unfold organically. And yes, a hefty sprinkle of magic.

This is a non-profit project and a labor of love. It was beyond an honor to connect with every single contributor, Kickstarter backer, and the hundreds of others who played their part, no matter how small, in creating this book. I now send it out into the world and trust the black cat tribe will rally to support not only the book, but the cause. Homeless black cats everywhere are eagerly waiting to be loved and adopted.

 Deep purrs of gratitude,

Layla Morgan Wilde

Our goal is to change perceptions about black cats one story and one photo at a time.

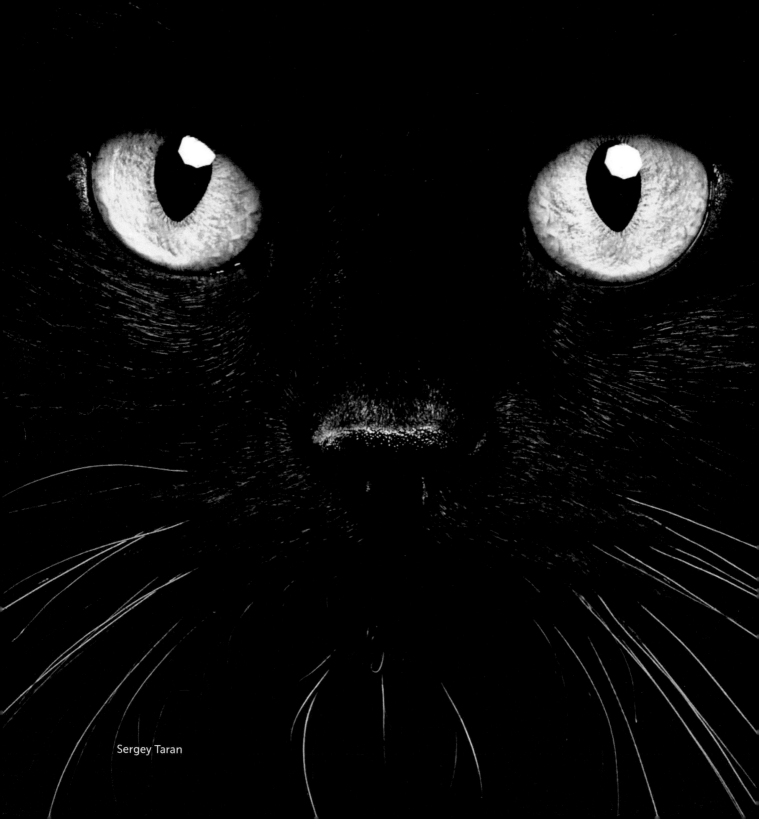

Sergey Taran

The Root of
Black Cat Superstitions

We can trace the origin of black cat superstitions to historical facts. On the 13th of June, 1233, Pope Gregory IX issued a papal bull (an official church document) titled the Vox in Rama. It declared that black cats were an incarnation of Satan. Anyone possessing a black cat could be associated with devil worship and witchcraft. The decree marked the beginning of the Inquisition and church-sanctioned heretic and/or witch hunts.

The papal bull is a fact, but the claims that led Pope Gregory to write it are dubious at best.

Pope Gregory appointed an inquisitor or heretic-hunter, Konrad von Marburg, a priest, to quell the growing numbers of Cathars, a Christian sect considered heretics. Marburg discovered a cult of alleged Luciferians in Germany. Under torture and threat of being burnt at the stake, they confessed to outlandish orgies and acts of depravity with black cats. The details of the rituals outlined in the Vox in Rama quickly turned Medieval Europe into a frenzy of cat killing as a protection against evil. Heretics become known as 'ketzer' from the German 'katze' for cat, forever cementing the relationship between heretic, witch, Satan and cat.

The tradition of sacrificing cats to Midsummer

Heretics become known as 'ketzer' from the German 'katze' for cat, forever cementing the relationship between heretic, witch, Satan and cat.

bonfires and cat torture as sport lasted into the 18th century. It spread from Europe to the U.K., and pilgrims brought their superstitions with them to America. Four hundred years later, in the U.S., the vestiges of prejudice and discrimination towards black cats linger. We've come a long way, but it's time to wipe the slate clean, once and for all.

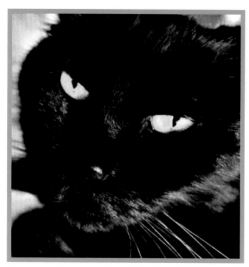

Clyde

Changing beliefs
happens one cat,
one person,
one purr at a time.
It begins now.

Follow this journey
of cat lives
from young to old
and in
all four seasons.

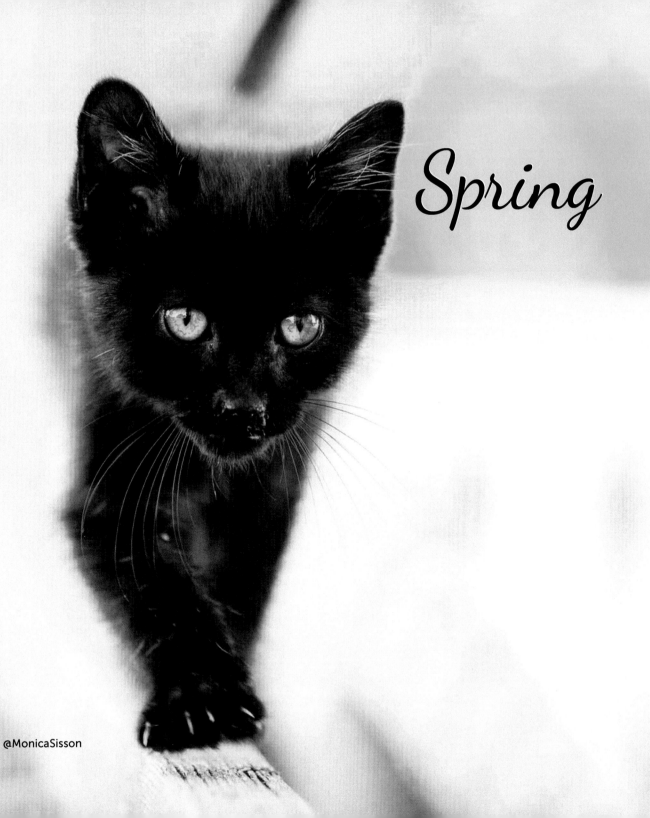

Spring

@MonicaSisson

Spring

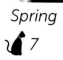 7

Anita, Austria

Nicholina

Sasha (mom), Frisbee, Boudine and Claudette

Robin & Kittens

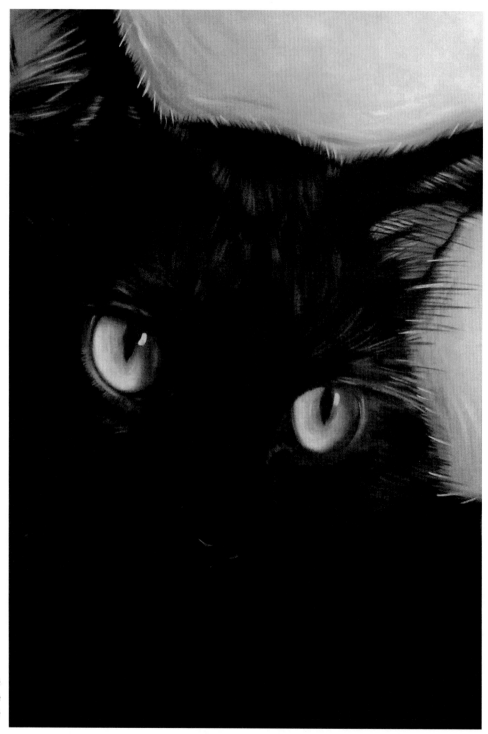

Painting of Cole
by Diane Irvine
Armitage

Shadow of Love:
The Story of Cole the Celebrity Cat
by Cole, with Jessica Josephs

Lights flash before my sensitive eyes, and I dart quickly across the hard stone, solid under my tiny paws. A noise above me. I cry out for help. Suddenly, warm hands surround me and hold me close while frantically searching for signs of my kind in the deserted wilderness. Time passes slowly, and eventually I am tucked away in a comforting embrace. I cry with joy that I have been rescued, but fear the unknown that lies ahead.

A day passes and I hear a soothing voice in the distance trying to find me a home. Why doesn't anyone want me? I have had the dirt washed out of my eyes and ears, my shiny black fur is clean and fluffy and the fleas have been meticulously removed from my petite body. The voice pleads that the color of my fur should not stop me from finding a loving home. I sit patiently, even posing for a picture and trying to look my most distinguished. Hours pass until I hear a cheer and shout of joy! The voice has found me a home! I am going to meet my new family the next day! I fall asleep cuddled in a soft blanket, excited and nervous for my new adventure to begin.

The next morning I am safely transported in a box where I pace anxiously and, to be honest, quite loudly, to meet my new family. The lid moves slowly, and as my delicate eyes adjust to the light, I look up into the kind face of my new Mom. I squeak for joy and try to use my fragile legs to jump into her arms. "Hello, baby face, I'm your new mommy. We're going to call you Destiny," she says as her calming voice ripples over my fur. She picks me up gently, cradling me to her neck as her warm breath washes over my tiny form. "I'm going to take you home and give you all the love you can handle. And then probably some more," she chuckles. As she places me gently back into my box, I plead with

her to hold me again. I know that I am going to do everything I can to show her love every day.

If I had any doubts in my heart and soul that this was the perfect Mom for me, they vanish when she softly hums and sings to me during the whole trip to my new home. I am still scared and anxious, but I try to concentrate on her voice and remember that without my rescuers and my new family, I could still have been lost and alone in the cold. Or even worse.

We eventually stop moving, and she slowly lifts my box, carrying me protectively. I hear whispering, and again the lid is slowly removed from my safe haven. Mom scoops me up into her arms and says "Destiny, meet your Daddy." I looked up into the smiling face of my new Dad and meow with joy. Both of my new parents hold me and repeatedly reassure me that now I am safe and can live with them forever. I jump with joy or at least the 4 inches off the ground my little legs will allow. I run around their legs excitedly, climb into their laps and snuggle as close as I can under their chins to show them how much I have immediately fallen in love with them.

Later that day, Mom and I have another adventure when I get to meet my doctor for the first time. Mom assures me it is just a checkup so they can take care of me the best ways possible. I only weigh 6 ounces and the doctor says that my birthday was probably 5 or 6 weeks ago. It also turns out that I am a boy, not a girl, so Mommy says my new name is going to be "Cole." We decided that I can keep "Destiny" for a middle name because it was destiny that Mommy's friend found me and saved me. Unfortunately, I am anemic because of all the fleas that are still on me. Mom warns me that I am going to have to have another bath, but that I will feel much better afterwards. I know my parents are only doing what was best for me so I trust them.

Everyone at the vet clinic is so friendly to me and keep saying "I don't know who wouldn't want this adorable little fluff ball!" I learned that other kitties who have beautiful black fur like I do sometimes don't find loving homes. I am shocked! I didn't do anything that would make someone not love me and start to wonder what I could do to help show other families. We black cats are just as lovable as any other. I was

"Cole with a goal"!

Over the next week, Dad stayed home during the day, so we got to enjoy lots of quality time to bond. My new Mom and Dad taught me so many things! They showed me how to go to the bathroom (thankfully, because I was pretty uncomfortable at times) and then how to use a "litter box" all by myself. I did have a little trouble getting into the box since I was so small, but I am proud to say I didn't make any messes outside it. Every day, they carefully warmed up food for me and fed me from a bottle. It was SO yummy that I was a bit too eager and ate too fast, but they held me gently and showed me how to eat without burping too much. Eventually, Dad helped me eat solid foods, too. Again, I was a bit too eager and had to hold still for him to take my picture to show Mom how I had gotten food ALL over my face. We had fun getting messy, and he tolerantly cleaned me up afterwards. I loved my life, but was still worried for all the other kitties who may not have been as lucky as I was.

One day as I stumbled around my new house elatedly, I turned the corner and ran face first into a giant! Mom and Dad introduced him as "Jack-Jack" who also lived there, but spent a lot of time outdoors. My new family had a Mom, a Dad AND a brother! I was overjoyed! I learned that Jack-Jack was almost 18 years old, and although he didn't want to play as much as I did, he was a great companion.

Mom and Dad were so thoughtful that they set up steps around the house so I could easily leap onto the furniture. I could even watch bird TV (aka the window). There were fluffy pillows and blankets in case I got too adventurous and fell, which I did quite a bit, although rolling around was fun, too. Jack-Jack showed me that we lived at an amazing big cat sanctuary where Dad worked. I could see huge black cats out my window and wondered if someday I would grow to be that big. I had to remember to eat all my food at meal times if I wanted that! Mom and Dad told me that the big black cat was

what they called a "leopard" and sometimes I was going to hear a "lion" roar REALLY loud, but to not be scared because they would protect me. I was so happy to hear that there were so many people helping all my cat brothers and sisters. The world may not be such a scary place after all.

As I grew, Dad's favorite thing to do was to videotape my shenanigans. We had so much fun being silly together. Mom would build me HUGE box forts to play in that reminded me of that first day I met her and the box that brought me to my new life. One of my favorite games was when Mom would put me on her lap. I would roll on my back and she would tickle my fluffy belly. She would tease me by holding her hand up and all I could do was squeak with excitement until she tickled me again. At bedtime, I would snuggle up on the couch, either under their chins or on their shoulders, and they would hum to me until I fell asleep. I tried to give them as many head bumps, kitty kisses and purrs as possible to show them how much I loved them. I didn't know if I'd ever be able to thank them enough for adopting me.

One day I heard Mom and Dad discussing taking some of the videos and pictures of our playtime to show other people how wonderful black cats like me could be. This was purrfect! This was exactly what I had wanted to do and now we could do this as a team! Dad finished putting all the footage I starred in together and so many people agreed with us that we decided to make even more videos to help as many cats as we could, no matter what color they were! I even won an award for the video Mom and I made during our tummy tickle game. My plan was in motion. I would use my new-found recognition to bring awareness to all cats that needed to find homes.

We worked every day to show the world that all cats, especially black cats, can fill your heart with joy and love. But as hard as we worked, there was always something missing in my heart. I wanted another kitty to share my joy, my playtime and my adventures. We had moved to a new home and Jack-Jack had stayed to live with the big cats. As fate would have it, Mom's job

was full of wonderful people who shared the belief that all cats deserve a loving home, and they were always helping save my kitty brethren. About a year after Mom and Dad adopted me, I got the best gift I could have wished for, a little brother and fur-mate, Marmalade.

Now together Mom, Dad, Marmalade and I all try our best to show the world the joys of adoption, or, as they call it, "being owned by cats," Sometimes when I stare out my window at the outside world, I think about all the black cats I am told are in shelters. The sad truth is that they are not adopted just because of the color of their fur, and my soul weeps for them. How lucky am I that I found a family that saw past the color of my fur to the heart of gold beneath! It's at these times that I climb into my Mom or Dad's arms and show them how much they mean to me.

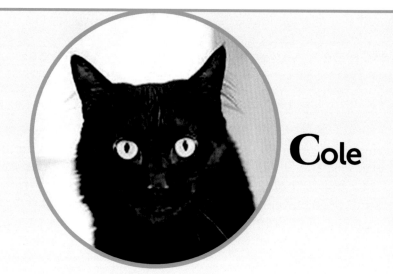

Cole

U.S., Illinois
Gender: Male, neutered.
Breed: Turkish Angora (we think).
Birthday: Sometime in 2012, celebrated on March 1st.
Zodiac sign: Pisces.
Weight: 13 fluffy, snuggly lbs.
Any unusual or special characteristics: Normal and fabulous.
Occupation: Director of head bumps. Video star. Spay/neuter advocate.
Religion: None.
Interests or hobbies: Cat treats, playing hide & seek, birds, squirrels, butterflies, going on walks.
Pet Peeves: Having my teeth brushed, weird noises.
Favorite quote: "One person can make a difference, and everyone should try."–John F. Kennedy
Social Media: Instagram @coleandmarmalade

Some kittens are destined to be working barn cats
while others, working models or meowdels,
like Sophie the Model or Lunz.

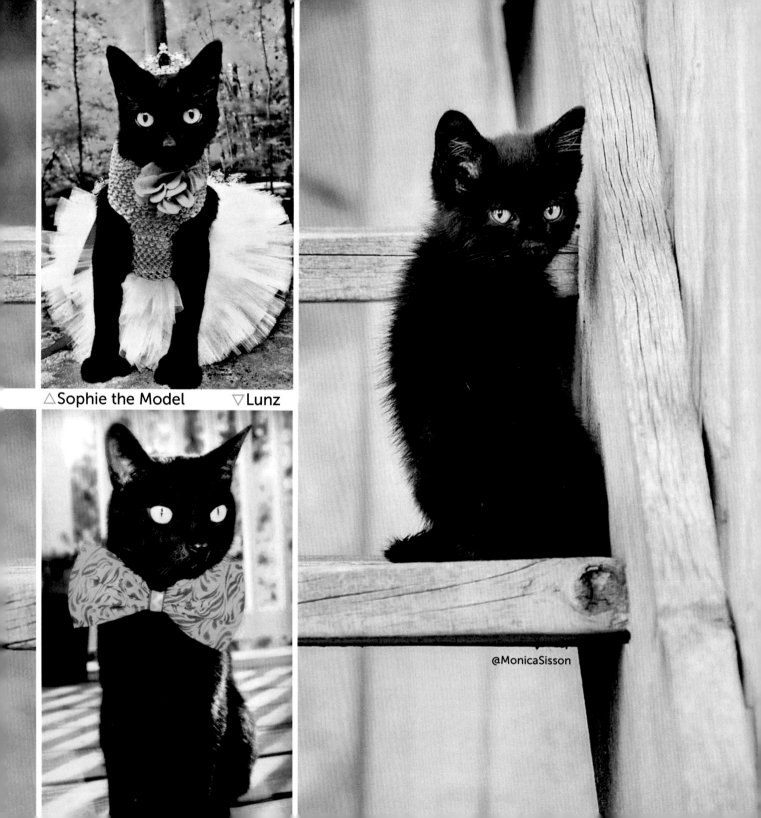

△Sophie the Model ▽Lunz

@MonicaSisson

Most cats live lives of leisure, but some cats have jobs.

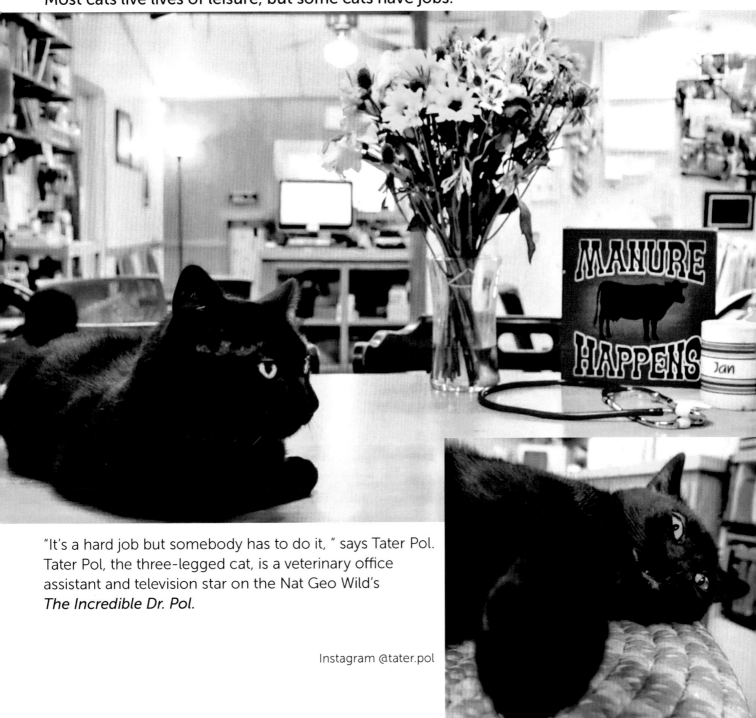

"It's a hard job but somebody has to do it, " says Tater Pol. Tater Pol, the three-legged cat, is a veterinary office assistant and television star on the Nat Geo Wild's *The Incredible Dr. Pol.*

Instagram @tater.pol

Cats at cat cafes like Beer, work hard (or not) to entertain patrons to get adopted. Yes, he's been adopted.

Instagram @konekonyc

Angus is a landscape designer's assistant in Edmonton, Alberta, Canada who lives at the office during the week.

Antonio

by Jennifer Markley

Antonio (Tony) was rescued from a road construction site in Texas when he was six weeks old. My best friend's husband was walking by the site after dinner and heard the kitten hollering for help. He got my best friend, Debra, and a flashlight and went back to rescue the little guy, but Tony wasn't ready.

The next day at work, Debra told me what happened, and I went at lunchtime to see what I could do. Although he wouldn't come to me, I left him some kitten chow and a bowl of water with ice. We went back after work with another friend, and between us, we were able to corral and lift the little guy to safety in my arms. I took him home, and he still has my heart. Although I saved him, I feel he really rescued me, as I had lost my brother and two other beloved cats to illness in less than a year. The joy and love of this amazing creature still brings me peace and comfort.

@antonioandfrankie

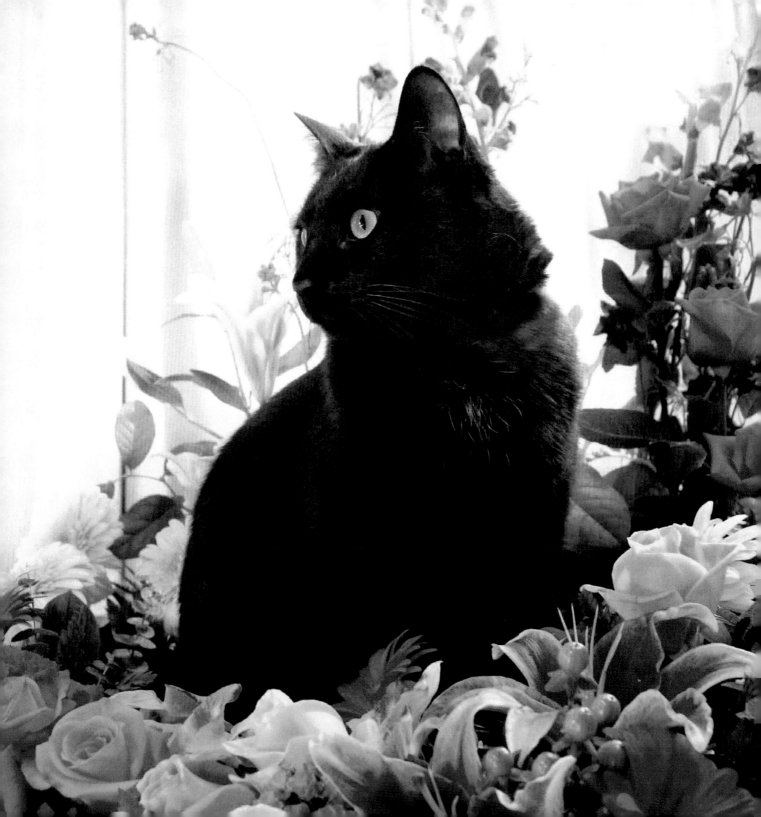

Merlin

U.S., Tennessee
Gender: Male.
Breed: Magical forest-dweller and feline familiar.

Birthday: Unknown. Gotcha Day: Oct. 12, 2015.
Zodiac sign: Aries.
Weight: 9 lbs.
Any unusual or special characteristics: Everything and nothing.
Occupation: Official Status Checker of All Things.
Religion: Pagan.
Interests or hobbies: Cat fort lookout, snuggling, kneading, bird watching.
Pet Peeves: Simon the Cat.
Favorite quote: "The cat does not offer services. The cat offers itself. Of course he wants care and shelter. You don't buy love for nothing." —William S. Burroughs
Why should people adopt black cats? Who wouldn't want a sweet, loving tiny panther? They are wonderful.
What is your idea of purrfect happiness? Sitting on my Mom's shoulder, watching birds outside the window.
What is your favorite food or treat? Catnip.
What is your favorite toy or game? The Track Ball.
Social Media: Instagram @cammycat

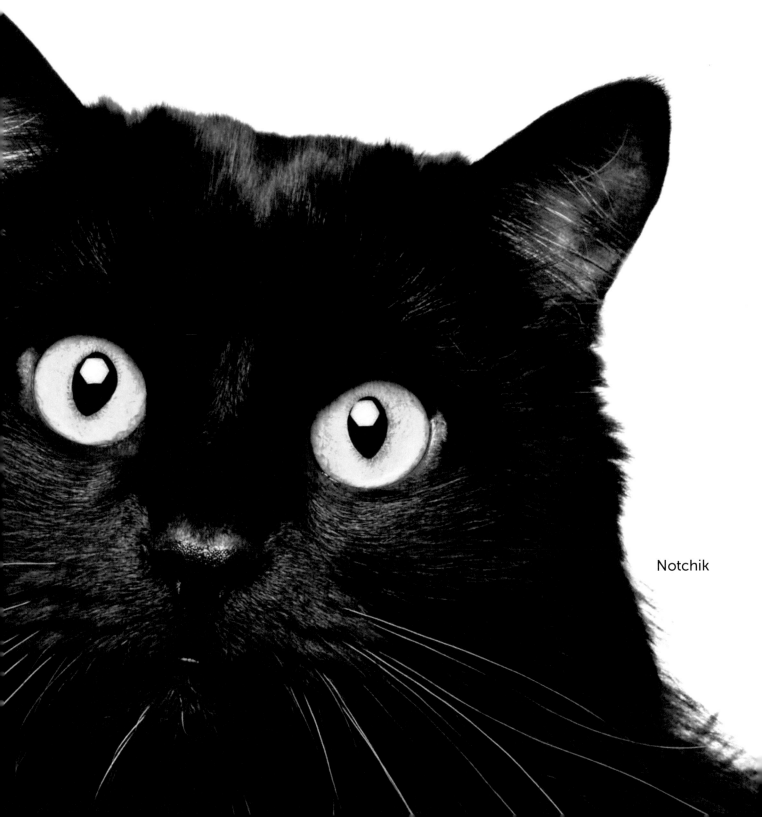

Notchik

Notchik: From Russia with Love

translated from the Russian by Sergey Taran
& Layla Morgan Wilde

In my country, we have many traditions surrounding cats. Some believe black cats are unlucky – but only if they cross in front of you. I don't believe it or I wouldn't have adopted a black cat. I found my cat in small village in Russia.

An elderly woman held out four or five black kittens. "You want one?"
I nodded.
"Choose your kitten, the one for you."
"How do I know which one is for me? They all look identical."
"Like this. Hold your hand on top of a kitten. If you feel the heat, then it's yours."
I held my hand on top of each kitten, and suddenly I really felt the heat from one.
"That's your girl!" said the old woman.
I called her "Nightly" and took her home.

A year later Nightly began to urinate everywhere. I thought it was her estrus, and I decided to spay her. Two hours later, I get a call from a vet. I get worried, thinking something went wrong. The vet tries to explain to me, but he can't stop laughing. He tells me how he instructed the nurse to prepare the black female cat for surgery. She shaves the belly and realizes she was a he. She runs back to doctor and says, "I think I shaved the wrong cat."

Still laughing on the phone, he says, "Congratulations, you have a boy!"

A boy, after a year! It was funny, confusing and shocking. I decided he deserved a new name and called him Notchik, which means Little Night. He inspired me to do pet photography and sometimes models for me.

 25

Instagram: @Seregraff

Kuro & Django

Belgium
Name Origin: Kuro means "black" in Japanese.
Gender: Male.
Breed: European shorthair (Kuro) and European longhair (Django).
Birthday: Kuro–May 22, 2011. Django–July 15, 2015.
Gotcha Date: Kuro–October 1, 2011 (walked into the house and never left). Django–September 12, 2015 (found as a 2-month-old kitten).
Zodiac sign: Kuro–Taurus. Django–Cancer.
Weight: Kuro–6 Kg. Django–4.3 Kg.
Any unusual or special characteristics: "Brothers from Another Mother."
Kuro: I always want to be around Django cat or my cat dad, Micha, and I love giving chin rubs. You could call me a really mellow and relaxed cat, but goofy sometimes, too (rolling on my back making noises). When walking downstairs, I announce each step with a 'meh' sound and take a flying leap off the last two steps. Poop and run cat. I run away fast after doing my business, leaving it uncovered.
Django: I'm Mr. 'Happy Cat' but get easily excited, always running, talking, walking in front of my cat dad's feet and love sleeping underneath the covers with him. Very proud of my extremely long floofy tail.
Occupation: Design and photographer's assistants. Aspiring models.
Religion: None.

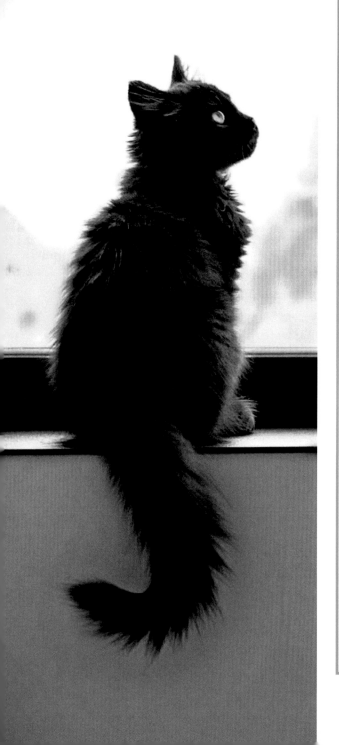

Kuro & Django

Interests or hobbies:
Kuro—Hanging around the other cats and my dad.
Django—Love running on the big cat wheel until heavy breathing with my tongue out like a dog.

Pet Peeves: Animal abuse and bragging about it on social media, (Trophy) HUNTERS and puppy mill breeders, people who abandon kittens and dogs!

Favorite quote: None come to mind: English is not our native language.

Why should people adopt black cats? Our cat dad who volunteers at a shelter says the black cats are always friendly and playful, their coat is like silk and shiny, and they move like mini-panthers. Little to no grooming issues. Black cats with yellow/orange or green eyes are stunning!

What is your idea of purrfect happiness? Having at least two cats in a family is a must (but a maximum of 10 to prevent group rivalry). Having our dad watch us finish our meal, lick themselves clean and then get ready to go to sleep. Relaxing in front of the fireplace or snoozing in sun puddles.

What is your favorite food or treat? Grain-free cat food and fresh meat. Treats—Catisfaction.

What is your favorite toy or game? The cat wheel.
Website: www.smashgraphics.be

Kuro

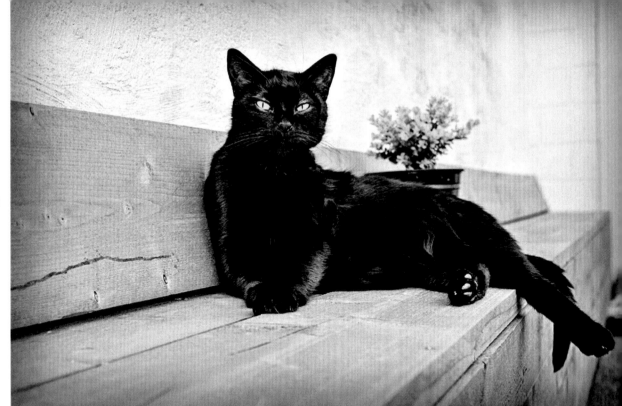

Django

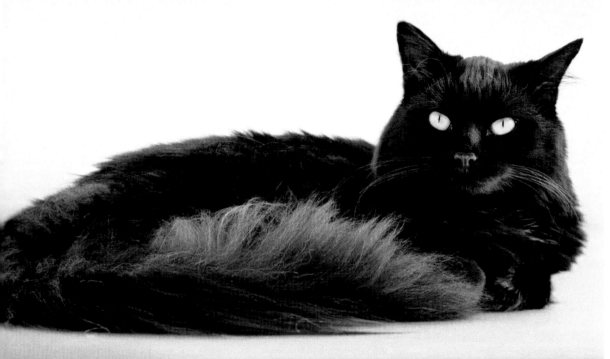

Three Lucky Black Kittens - Buddha, Ziggy & Lucky – A True Story

by Prince Buddha, with Chase Holiday

Since I was a kitten, my human, Chase Holiday, has told me this bedtime story. Now I would like to share my story with you.

My mom is a chocolate brown Siamese cat named Brownie. She adopted a man named Styles Caldwell. She showed up one day and moved into his single-room apartment in Hollywood, California, with his cat, Johnnie. Styles was a cat lover and an eccentric character. He had a glam career as an actor in the Andy Warhol crowd in the 60s and 70s. At first my mom was very shy, but slowly she began to trust Styles. She surprised him one week later, on St. Patrick's Day, by having three black kittens in his closet.

Styles had seen the big black tomcat near his apartment and figured he was my father. My mom proved to be a very good mother, and we moved in permanently. Styles asked his friend Chase Holiday to help him find homes for us. But then he decided he would keep us all. He called Chase daily with stories of our kitten progress. "They opened their eyes. They have left the closet. They can jump on the bed. They are eating wet food."

It was very hot in Hollywood the summer I was born. And with the heat came lots and lots of fleas. Styles's apartment was an old Hollywood 1920s bungalow with a beautiful courtyard. The courtyard became infested with fleas in July, and we were in the hot seat. The evil landlady, Prudence, pointed her finger at Styles, screaming at him and blaming his cats for the fleas. Styles

was beside himself. The cats were his family. He called Chase and begged her to help. She contacted the evil landlady to see what could be done. After several long conversations, Prudence said Styles could keep Johnnie and Brownie, but the kittens would have to go within 48 hours. He would also have to de-flea the two cats and keep them indoors.

Chase knew a single mom named Diana and her two tween-age girls who adored cats. They were not allowed to have any in their apartment, but they said they could temporarily foster the kittens until homes were found. We were now over three months old.

Chase and her good friend Kathie Gibboney came to get us. Chase told me that on the way they had stopped off at the 1920s restaurant, El Coyote, had margaritas and reminisced about their younger punk rock musician and actor days in Hollywood. They arrived with cat carriers and treats. For some reason, they were horrified by the messy apartment where we lived. Okay, there was junk everywhere and we did not always use the litterbox. Chase and Kathie quickly realized we were not socialized. We were terrified of them and immediately made a beeline for under the bed. How did we know they were there to help us? It turned into a bad Marx Brothers film or a feline version of Whack-a-Mole. They'd catch one of us, then another, then one of us would escape and they'd have to start all over again.

My brother Lucky bit Chase's hand, hit a vein and her hand instantly blew up like a giant balloon and became infected. That ended her cat catching. I will never forget the horrified look on Kathie's face when Chase told her she'd have to get down on the dirty carpet in order to reach under the bed and get me. Somehow they captured us and limped away. Everyone was a mess. We never made one peep the entire car ride back to Santa Monica. Kathie and Chase didn't talk much either. I guess it's hard to drive a car with a giant balloon hand.

Three Lucky Black Kittens -
Buddha, Ziggy & Lucky –
A True Story

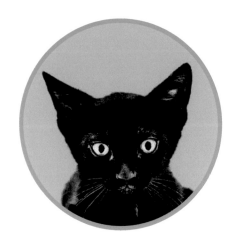

Chase and Kathie delivered us into a small bathroom and left. We hid in the bathtub. They had brought supplies such as food, a litter box and toys. We were so scared and missed our mom. We had no idea what had happened to us. Diana and her daughters came home later that night and opened the bathroom door. Quickly we decided to make a beeline for under their bed. More strangers. It was all too much and we hid for the next three weeks. The girls talked to us nicely and they were so cute, but we were very scared. We would come out and play when everyone was sleeping or not home.

Chase had no idea how hard it would be to find homes for three black kittens. Nobody wanted us. The no-kill shelters refused to take any black cats since Halloween was just around the corner. People told Chase black cats were bad luck. She couldn't believe people believed that. For weeks she asked everyone she knew, sent emails, put up flyers, advertised on Craigslist, got hate mail. Many times Chase was close to adopting us, but nothing ever panned out.

Then it was time for the foster family to leave town for the month. They had a house sitter named Tabbi staying in their house. Tabbi agreed to watch us kittens for a few bucks. If you are going away on vacation, be very careful who you choose as a cat sitter.

It became apparent that Tabbi hated us. She spoke to us in a mean voice and complained that we kept her up all night. She barely fed us and never, ever cleaned our litterbox. After a couple of days, a rescue lady came and tried to capture us, but we stayed under the bed and she couldn't get us. We were proud of ourselves for that. But then two days later Tabbi tricked us and trapped us in the bathroom. She threw us all in a carrier, calling us evil. She put us in the car and drove away.

Chase kept checking in with Tabbi via email and Tabbi told her we'd been adopted. Chase sent an email that said

"Thank you, I'm so relieved, but I think it's strange you would let them get adopted without consulting me. I'd like to know more details." She kept calling Tabbi, asking what happened to us kittens. Tabbi did not return any calls or emails for many days. One of the foster girls started to call too. "Tabbi, where did the kittens go? Please call us right away." Everyone was starting to get very worried. Finally, Tabbi responded and accused Chase of harassing her and said she was going to call the police. She said a rich lady in Malibu had adopted us, but she did not have the contact info. Tabbi was very vague and the details were not adding up. Thank the cat gods for women's intuition.

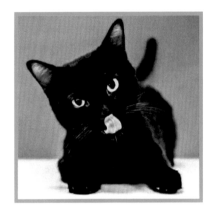

Chase was desperate to find out what had happened. She went to see a cat rescue lady who was often on the street near Tabbi's work to see if she knew who had us kittens. Yes, she knew all about the three black kittens. The rescue lady told Chase she had tried to catch the kittens the past weekend, but couldn't get them. Tabbi hated the kittens and said they were bad luck and ruining her life. The rescue lady said she didn't have any room for them, so Tabbi took them to the Santa Monica Animal Shelter. Chase told me later, "At that moment everything got hazy and dark like a bad dream," I began to mew from the bad memories. The cage place. "Tabbi had lied and I had to save you."

She rushed to the shelter and was relieved to know we were still alive. We were in an isolation room marked "FEARFUL" because we were so scared. They told Chase she could adopt us for $110 each. She didn't have the money. When she explained they were her kittens and had been stolen, they said there was nothing they could do. A nice employee said he thought they'd be adopted. He said she could visit as often as she wanted. Since she didn't have the money to get us, she left and cried the rest of the day. Chase called the foster family in San Francisco and told them what happened. Uh-oh, Tabbi's got some explaining to do.

Three Lucky Black Kittens -
Buddha, Ziggy & Lucky –
A True Story

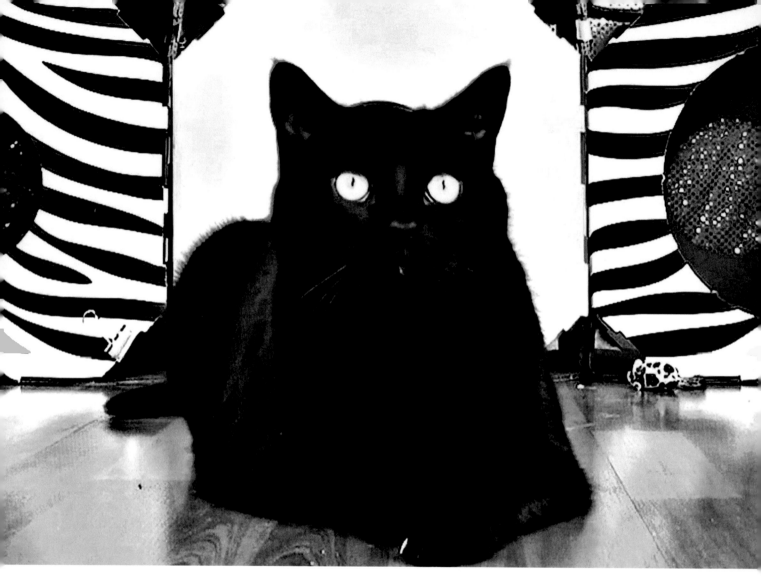

 Chase came back to the shelter the following three days, but was not allowed to see us again. There were sick cats in the room where we were kept. We had been separated into different cages and I was so scared without my brothers. I would just hide in the back of the cage. On the third day, we heard a very mean man say some kittens were going to die that day. Black cats could be first since they were hard to find homes for. Chase panicked and ran to the front desk to see what could be done. This time they advised her to go to the police and file a report, which started a wild goose chase. The police said it was complicated and called the Animal Control Supervisor. They said they would have to talk to the owner of the apartment, Diana, who was away in San Francisco. The police arranged a call with Animal Control Supervisor the next day. After Chase explained

the whole story to him, the Supervisor finally agreed to let her have the kittens, waiving the $330 fee as long as she guaranteed we would be fixed. She brought us home to live in her guest bathroom. Here we go again. Another bathroom.

We hid under the vanity for three days. Hiding is what we did best! There were other cats in the house that would talk to us on the other side of the door. They told us their human, Chase, was cool. On the third day we all came out from under the vanity and started to purr. Something felt different this time. After knowing all kinds of people in our short lives, we knew Chase loved cats, for real.

After a few days, she decided to put us out on the Catio for the day. Her four cats, inside, could watch us like kitten TV. After a few more days of this kind of intro, she let us into the house. The house was huge, filled with toys, and we could run wild with the other furballs in playtime-central. And joy of joys, clean litter boxes. Never underestimate simple pleasures.

She named us Lucky, Ziggy and Buddha. Ziggy had a crooked tail, Lucky had a white whisker and I was calm and very sweet. That's how she could tell us apart. Lucky and Ziggy were partners in crime. Her cat Yogi often joined them in mischief and wildness!

Chase took new pictures of us and continued to try and find us homes. Then one day she took us out on the Catio and made a YouTube video. We were stars. The response was amazing.

A neighbor who had seen the video wanted to meet us. Two hours later, Lucky and Ziggy were gone. We were in shock. Everyone was moping and depressed. Where were Lucky and Ziggy? I was told the neighbor who had adopted them was wonderful. And Chase could visit anytime, so she was happy. The neighbor said she'd bring them to visit. (And did!) The four

Three Lucky Black Kittens -
Buddha, Ziggy & Lucky –
A True Story

furball cats immediately took hold of me and said we are not letting you go. They told Chase, "We're keeping this one." It never occurred to her that they'd have a say in it all. But she was torn. She had not considered keeping one of the kittens. She already had four cats. But in her heart she already knew she would keep her sweet black cat Buddha. And so, that's I became the fifth furball and our YouTube channel Furball Fables was born.

My own purrsonal mission is to let humans know black cats are lovable, lucky and super cool!

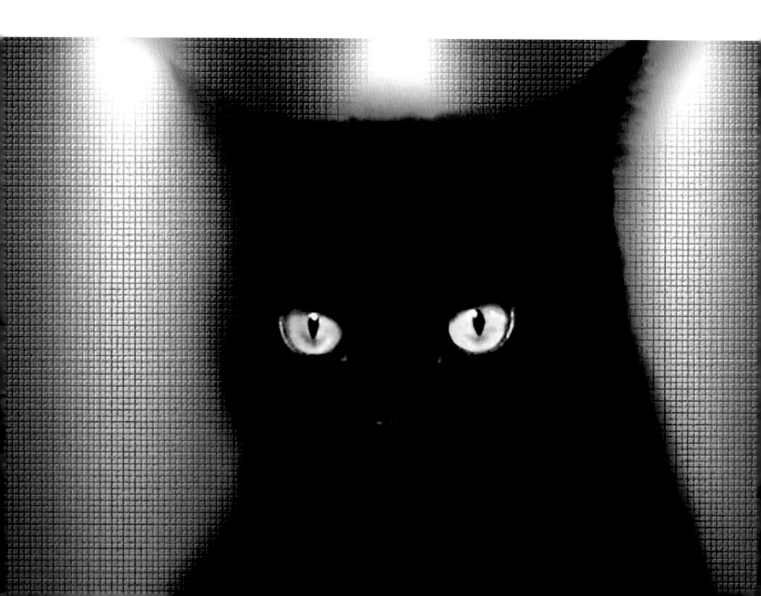

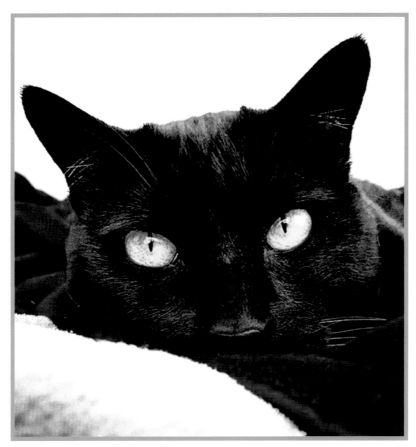

Wingnut

Wingnut's Story
by *Wingnut, with Gina Cook*

I was discovered with my newborn siblings beneath a porch in Georgia. My rescuers found homes for us all, except the black kitten: ME. The rescuers asked friends to consider adopting me, but they worried they couldn't commit.

Days later, Human #1 received a text from the Rescuer: "going to Florida for funeral, we're scared to travel with the kitten..." Human #2 suggested "kitten-sitting" for the weekend; #1 replied to the text, "I'll pick her up Friday."

It was November 13, barely a year after #1's Mom, renowned for helping animals, had died. Human #2's convinced I was heaven-sent to dispel #1's grief and rescue them both. Eight years later, they're still "kitten-sitting," lucky them!

Wingnut

U.S., California
Nicknames: Wingle, the Winglenator, Winglet.
Gender: Female.
Breed: Domestic Shorthair.
Birthday: Sept 13, 2009.
Gotcha Day: Lucky Friday the 13th of November, 2009.
Zodiac sign: Virgo.
Weight: 12 lbs.
Any unusual or special characteristics: I am a mast-cell cancer survivor, with snowy white spots from strontium radiation.
Occupation: World's Cutest Kitten and member of LEBC (League of Extraordinary Black Cats).
Religion: Buddhist – except when it comes to hunting spiders.
Interests or hobbies: Watching NFL with my humans (seriously!). And butter. I also love rocks, and folks have sent me rocks from all over the world.
Pet Peeves: Not being given butter immediately upon demand.
Favorite quote: "There is no such thing as 'just a cat.' "
–Robert Heinlein
Why should people adopt black cats? To illustrate their personal intelligence and demonstrate they can think for themselves rather than buying into myths perpetuated by "sheeple."
What is your idea of purrfect happiness? Being fed butter while watching football with my humans, rolling around on my rocks, and for all black cats to find furever homes.
What is your favorite food or treat? Butter and human toes.
What is your favorite toy or game? To rabbit-kick the Human! Polar Bear is my BFF, Stringmonster, my nemesis.
Social Media: Instagram @wingnutcook

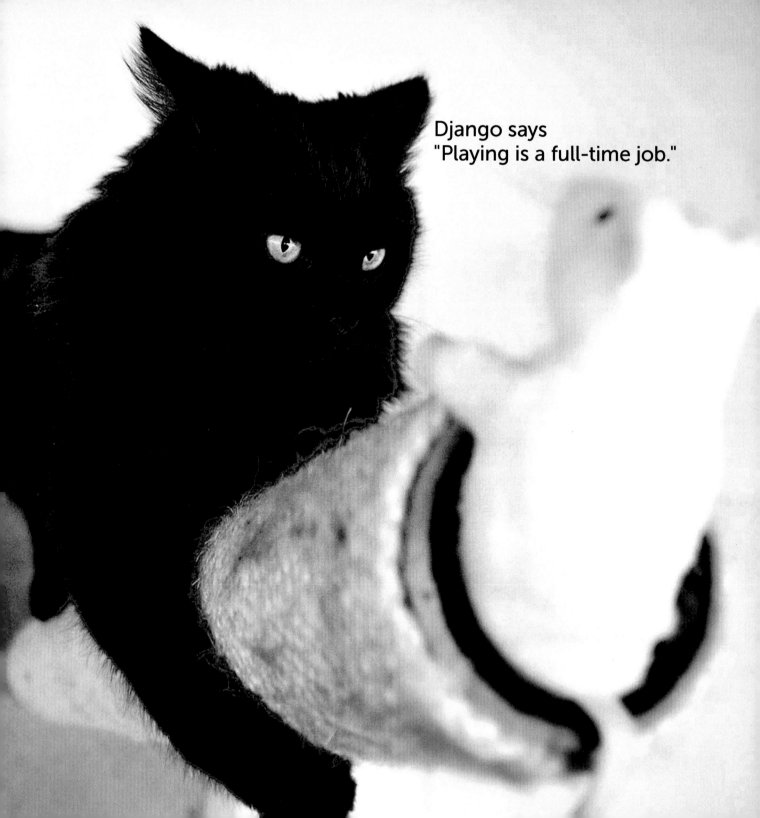
Django says
"Playing is a full-time job."

Cole chasing his nemesis the red laser dot.

Jack from @the_jack_k with his favorite toy, the Blue Dragon named Steve. Fur sister Alice (below right) in the tunnel.

Kami

Alice

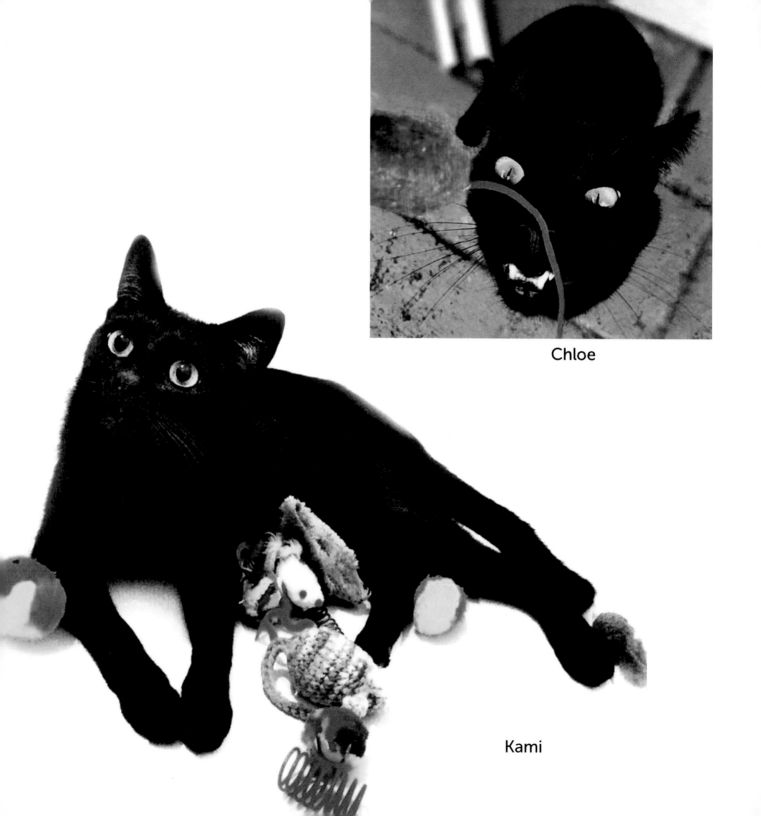

Chloe

Kami

Dillinger

by Jon Glascoe

Seven years ago, I was recently divorced, unemployed, and severely depressed. During that difficult time, I was visiting a friend when I heard a desperate meowing from a tree right outside the building. I came out to see a lean, silky black cat crying on a branch about five feet off the ground. His claws were incredibly long and sharp, but he did not hurt me at all as I pulled him out. I held him and for a few minutes he purred contentedly. When I set him down, he went right to the dirt at the base of the tree and took a long whiz, as if blaming the tree for getting him stuck. Then he rubbed his body against my legs over and over, and I knew then that our fates were joined. So I found a box and took him home and named him "Dillinger." We've been looking out for each other ever since.

*W*ho has sent you to me, Little One?
What put you up in that tree and made you cry?
You are hunger and love, Little One.
I am your map of the world, realized.

Breaker of mugs, meowing for meow's sake.
Hoarder of pens and coins and lighters and such.
No friend of moths, and would-be bird assassin.
Your teeth, ivory poniards. And your coat, ebon mercury.

Who done sent you to me, Little One?
What put you up in that tree and made you cry?
We are cut from a cloth, Little One.
We are cut from a cloth, and realized.

Yawner of yawns, all stretched-as-stretch-can.
Long fluid arc risen from fur and bone.
Patiently listen to my unending woes.
Hammered-brass eyes now slits, unto sleep.

My little shiny Black Boy.

Dillinger

U.S., New York
Nicknames: The Dillinger Escape Cat, D, Young Money D, Young Moolah Dizzo, the Brooklyn Panther, the Cat-Prince Of Brooklyn, Boy, and "Hey Cat!"
Gender: Male.
Breed: Domestic Shorthair (but I suspect I may be at least part Bombay).
Birthday: January ? 2009. (Guesstimated – I'm a stray, after all.)
Gotcha Day: My cat dad (aka my Dummy) found me and took me home on September 20, 2009.
Zodiac sign: Aquarius.
Weight: 14 lbs.
Any unusual or special characteristics: I am highly affectionate, and I often follow my Dummy around our apartment like I was his shadow. I have been known to jump into the Dummy's arms from the couch or even the floor when I am especially anxious to see him. I am extremely vocal, with a beautiful speaking/singing voice that has been unfairly characterized as a "grating, whiney meow." I am an expert-level mouser, having caught 5 mice in our current apartment. I have slain three of them. (Don't ask about the others!) I have an exceptionally shiny and lustrous coat. The Dummy says I am like a "Cat-shaped oil slick". I love carbs! (Bread, cookies, muffins, etc.)
Occupation: President and Commander-In-Chief of THE LEAGUE OF EXTRAORDINARY BLACK CATS.
Religion: Orthodox Pantherist.
Interests or hobbies: Draping myself over the Dummy and the Woman like a cat-skin rug. Hearing the sound of my own voice. Being directly in the way of whatever it is the Humans are trying to do.
Pet Peeves: My little Sister, Mews. Also when 'Game Of Thrones' tried to make everyone think Jon Snow was killed off.

Dillinger

Favorite quote: "I meant what I said and I said what I meant. A black cat is faithful, one hundred percent!" – Theodor Geisel, aka 'Dr. Seuss' (paraphrased)

Why Should People Adopt Black Cats? Because Black Cats are the least likely to be adopted, for utterly ridiculous – and bordering on INSANE – reasons of archaic superstition and frightful ignorance. That needs to change immediately. Also: since black is the sum of all colors, adopting a black cat is like having a little bit of every breed rolled into one. That's just "science," people!

What Is Your Idea of Purrfect Happiness? My purrfectly happy day is any day (usually weekend or holiday) that I can lounge with the Dummy and the Woman on the couch and watch TV and get scritches and maybe a spoonful of yogurt – and smack Mews if she does something to displease me. Preferably during the winter, because that is when I enjoy snuggling the most.

What Is Your Favorite Food or Treat? The Humans feed me BFF brand wet food by Weruva, which I adore because they use real tuna in all of their flavors! For dry food, I enjoy Natural Balance Limited Ingredient Duck and Green Pea Formula. And I love Orijen freeze-dried treats.

What Is Your Favorite Toy or Game? I've never been a particularly 'playful' cat, even in my early years. The Dummy says that I must've emerged from my birth mother as a fully-formed adult, like Athena from the head of Zeus. Sometimes I like to wrestle with the Dummy's hand, but I often become agitated very quickly. As for toys, I do occasionally enjoy things with feathers, such as 'Da Bird.' I also like anything with catnip inside, but those items are usually taken from me before too long, because I will rip whatever toy it is to shreds in order to get to that sweet, sweet nip! To be honest, my favorite plaything has always been a simple crumpled up ball of paper. I'm just old-fashioned, I suppose.

Social Media: Instagram: @the_fulton_zoo

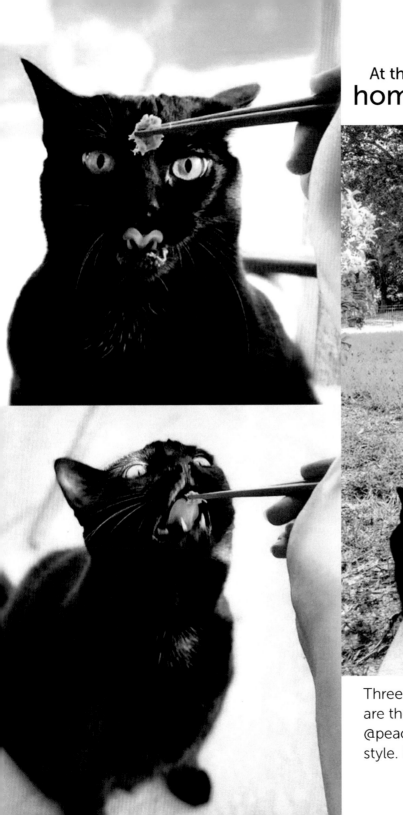

At the end of the day, there's no place like **home**, no matter where in the world you live.

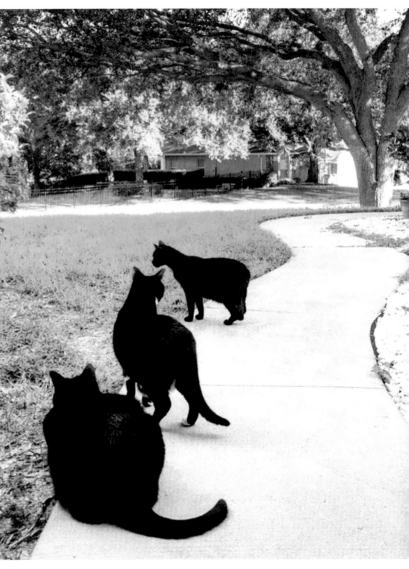

Three fursibs Pretty, Princess and Pooh Bear are the welcome home committee for @peaches.2020 where treats are served sushi style. Pretty says, "Pretty good. More please."

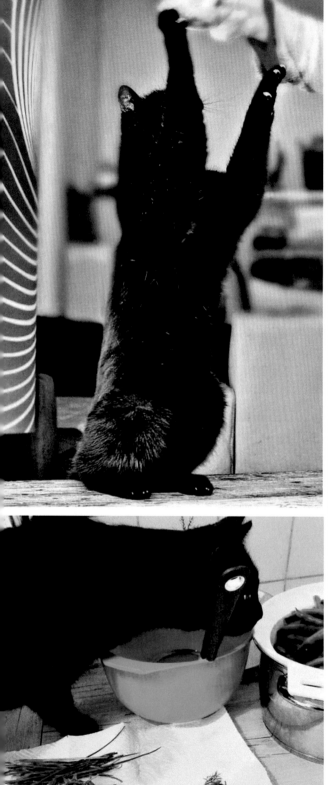

"Dinner is served," Rufus from Germany says,
"is understood in any language."

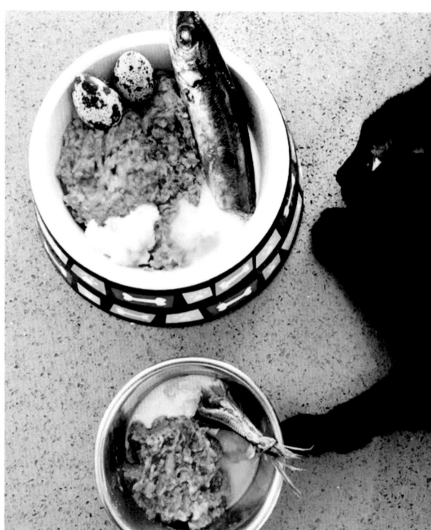

Otis from Ontario, Canada contemplates
eating his dog brother's raw-fed dinner.

Every chef needs an assistant like Blackie in Finland.
Instagram @Tiina_Bohlingsalonen

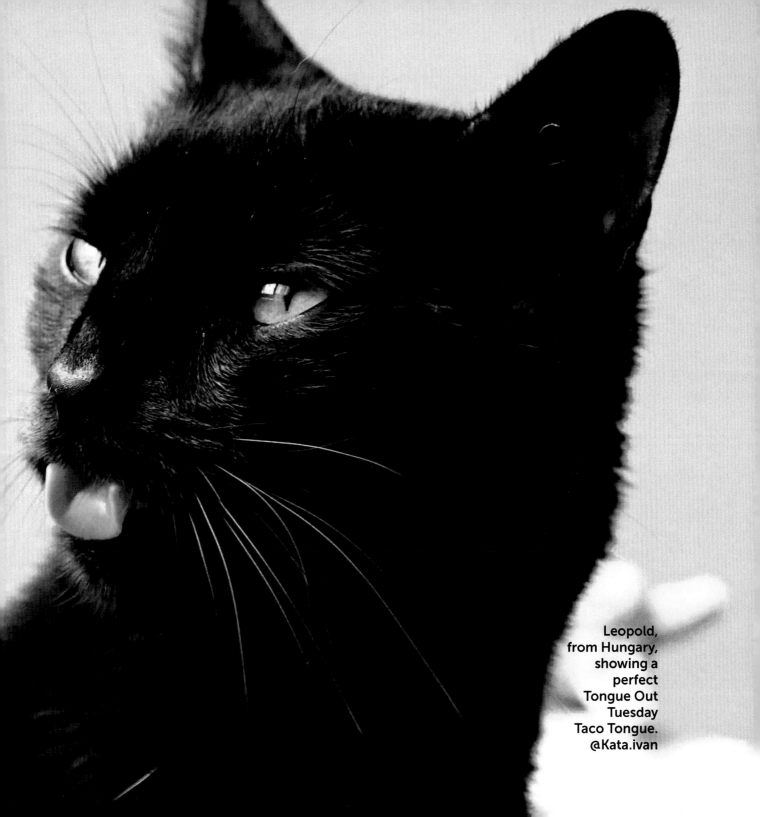

Leopold,
from Hungary,
showing a
perfect
Tongue Out
Tuesday
Taco Tongue.
@Kata.ivan

Leopold

Is this the face of "feed me?"
Antonio loves to share tastes with his human for any meal–chicken, pork, fish, lean cuts of beef, bacon, cheese, whipped cream, butter, cream cheese–life is a feast!

Nothing beats after dinner
lounging for Scruffy Sung
watching TV in the U.S.

Mordor the Maine Coon
gets cozy in
Moscow, Russia.
Instagram @mordor_cat

Maya loves lounging in her parents' bed (excuse me, her bed). They all love their folks to the moon and back.

Kooty the Persian in the Middle East enjoys fine Persian rugs.
Instagram @kootythecat

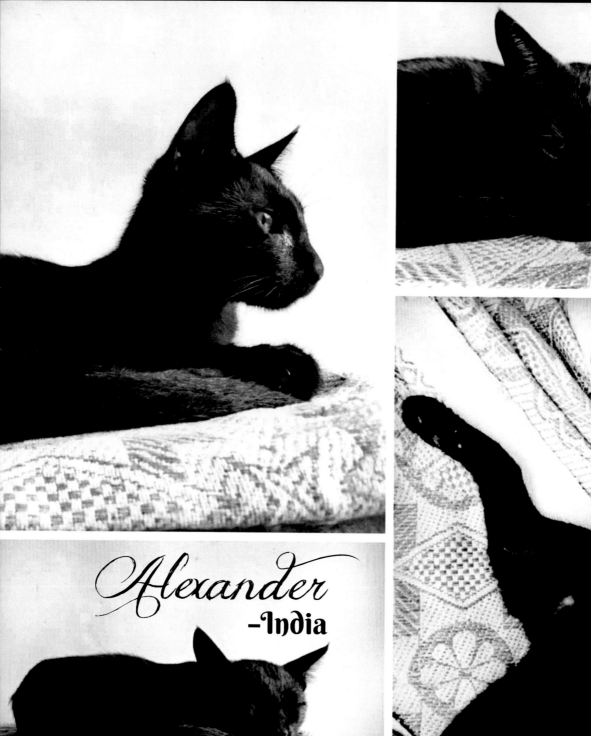

Alexander
-India

Bruce, the fever coat kitten from New Zealand, was born pale grey and as he got older, his coat gradually changed to a rich black,

Bruce, today.

Snuckles, the dashing
cat, world traveler,
and children's
advocate, is spreading
the message of
Black Cat Love
with his dad,
pro baseball player,
Sam Dyson.

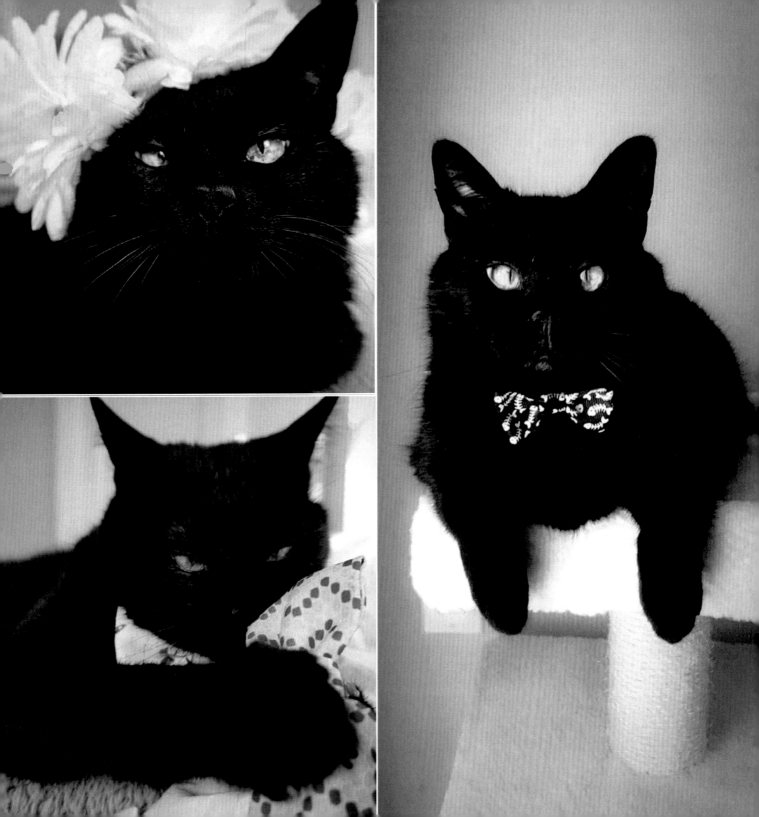

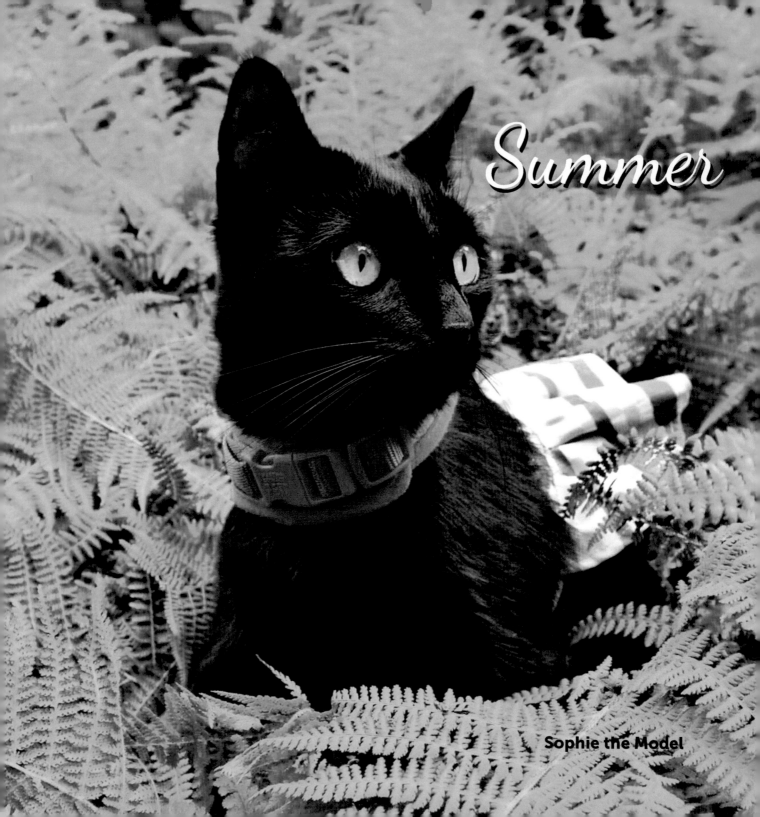

Summer

Sophie the Model

Genta Sueyoshi

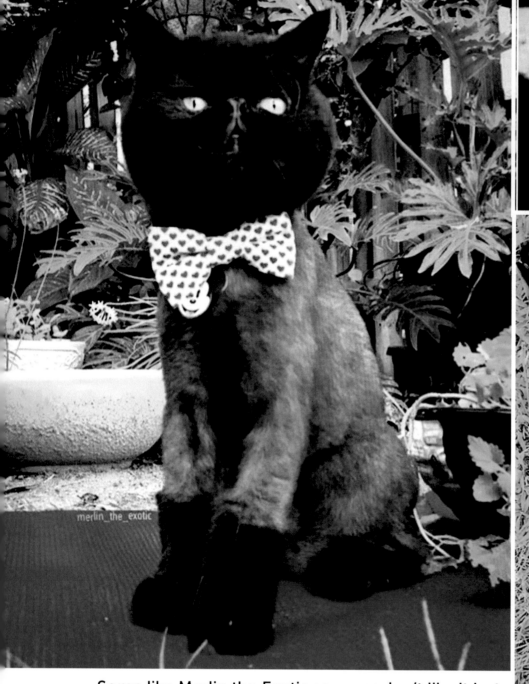

merlin_the_exotic

Some like Merlin the Exotic (above left) don't like it hot, while others like Momo (above right) & Fritz Patrick Fantastic (bottom right) prefer to chill in peace.

Penny's summer fun is playing hide and seek in the grass.

Bronte (above) &
Fritz Patrick Fantastic (right)
are enjoying the
summer of love.

Genta Sueyoshi

Yin and Yang

by Yin, with Alasandra Alawine

I don't have a really dramatic story like some black cats do, but I think a lot of cats and humans can relate to my story. You'll get no fancy talk or big words here. I'm just a regular cat who hit the kitty adoption lottery.

It actually starts with a solid white cat that Mommy's friend, Tammy, calls Snowball, in memory of Mommy's first cat. Mommy's friend works at a law office in a residential area. We think Snowball's people probably moved off and left her. Anyway, Snowball started showing up at the law office when Tammy was eating lunch on the back deck, and Tammy fed her. Pretty soon Snowball had kittens and Tammy fed them, too, and then the kittens had kittens and then before you could blink there was a semi-feral cat colony living at the law office.

There is one lady that does low-cost spay and neuter for our entire county, and as you can imagine, it's a really big job for just one person. Tammy works with her to get as many of the cats and kittens spayed and neutered as she can, but since green papers are in short supply and it's hard to trap some of the cats, there are always some unspayed cats popping out kittens.

So one hot August day a little calico girl who was barely 6 months old gave birth to me and my brother Yang (he is black and white) and an orange tabby, Linus. Being so young, she wasn't a very good mommy cat, and she didn't do a very good job taking care of us. When the lady came to trap the cats, they caught her, but released her when she saw she was a nursing mom. You'd think she would run back to us, but she ran off and left us. Thanks, mom.

Tammy called my future human Mommy in a panic Friday afternoon. The law office would be closed for the weekend, and there was no one to look after us, so could Mommy please take us and bottle feed us, just for the weekend. Mommy knew to bottle feed three kittens every couple hours would be exhausting, but realizing how hard it is to find homes for black cats, she agreed to take me and Yang, for the weekend.

(Don't worry, Linus got a home with a really nice man and his cat Lucy.)

Well, once Mommy saw us I could tell by her bug-eyes she was really upset. One side of my head looked deformed and swollen to three times its normal size, and I had trouble lifting my head. One of Yang's eyes was crusted shut. Mommy called the veterinarian, but they were already closed, and made arrangements to bring me and Yang first thing Saturday morning.

As soon as she got us home, she gave us a nice warm bath. Oh, it felt so good to get the yucky crusties off. When Mommy put the warm washcloth against my face, pus came pouring out of my eye and I was able to lift my head again. Magic! Then Mommy put us in Fenris's dog crate with a litter box and nice furry rug to sleep on and she gave us some canned kitten food and some kitten formula. I started drinking the formula right out of the bowl, and Yang started eating the food. It turns out we weren't too young to eat – we were just too sick to feel like eating, and the warm bath helped us feel better.

When we went to the veterinarian the next day, we got a flea treatment, got poked and handled every which way by cold metal things, endured bright lights and huge human paws. They gave us medicine for our eyes, and no one likes medicine, but kittens are at the mercy of their caregiver. It could be worse. At first I wasn't too friendly with the humans, but I was always cooperative when Mommy put the medicine in our eyes. I was shy and aloof, but I enjoyed playing with the ball Mommy gave us and watching Mommy. Humans are very entertaining to watch.

The youngest Human Boy spent lots of time playing with us and I really liked him. Then Yang almost died from coccidiosis, that's a fancy name for an intestinal parasite. He had to spend the night and most of the next day at the Emergency Vet. I missed my brother so much. I sat in Mommy's lap all day until she went to get him. I was very happy to see him when he finally came home. Worms are very contagious, and if one kitten in a litter has worms, they all do. I had to be de-wormed and took my medicine like a very good girl without any trouble. And bonus, I really bonded with Mommy. So much for

keeping us for the weekend! You guessed it, we found our forever home. I never did see my real mom again and hope she didn't have another litter of sick kittens.

I am a mama's girl and she calls me her shadow, but wait! It didn't happen overnight. Daddy said we had to go, that we couldn't have four cats (where do humans get these ideas?) and that Scylla, the Calico Terrorist, wouldn't like it if we stayed. By then it was October, and we were well enough to find homes. Mommy gave in to Dad, put a flier up at the veterinarian's office, and insisted on references. A lot of rescues don't even allow black cats to be adopted in October for fear of Halloween "pranks," or worse. Daddy insisted that me and Yang had to be adopted together, so guess what? No one inquired about us. Nope, not even one person wanted to give me and Yang a home. Not separately, not together. Nothing.

In November, Mommy told Daddy he could put up flyers at work advertising me and Yang for adoption, but he finally came to his senses. He said since Scylla had accepted us, we could stay and be a part of their family.

Daddy was right about one thing: they couldn't have four cats. It turns out five was the magic number! In December when they were visiting the grandparents for Christmas, Daddy almost stepped on a tiny kitten that didn't even have its eyes open. They brought the calico cutie home, and Mommy had to bottle feed her. I was her assistant in the chair, supervising the process. I have to say, Mommy does not do a very good job stimulating kittens, I saw right away I needed to take over that particular task. You see, mommy cats lick their kittens to help them pee and poo, and if a young kitten is orphaned, someone must stimulate them. Humans usually use a warm, wet washcloth. I knew I could do a better job and convinced Mommy to let me try. Soon, I became a surrogate mom cat for Chimera.

As Chimera got older, I made sure that Yang didn't play too rough with her. I let Scylla know that while she could box Yang's ears all she wanted (he deserved it most of the time), she couldn't hurt Chimera or she would answer to me. And I showed Chimera how to eat solid food and drink out of a bowl.

Yin and Yang

While I have a really nice life in a really nice home, my heart breaks for all the cats and kittens that don't have homes and the ones in shelters that get overlooked. Socks (the senior kitty here) has told me about several black cats that used to live here. I will briefly mention Princess, if that is okay with you.

Princess was a 6-month-old black beauty (Mommy says she looked like me) when Mommy and Youngest Boy adopted her. She had spent her entire life until then in a cage. Her mother was taken to the YMCA Pet Shelter when she got pregnant. She gave birth in a cage at the shelter, delivering several kittens. Princess was the only solid black one. Once they got old enough, Princess's siblings were adopted, but no one wanted her. I am sure this made her very sad, especially after her own mom got adopted and Princess was left all alone.

When Mommy and Youngest boy brought Princess home, she didn't know how to jump or play or do any of the things cats normally do. Luckily, Whiskers (a black tuxedo cat) lived here and was able to teach Princess about being a cat and how to act kittenish. But her days in her forever home were numbered. Not long after coming home, Princess had some sort of seizure and died before they could get her to the veterinarian's office.

Maybe it was Princess's unfortunate beginning that sealed her fate. Stress during pregnancy isn't healthy. We'll never know the reason she died young, but it made the humans want to give another black cat the chance for a happy long life. And along came me and Yang!

I hope that when you are looking to adopt a cat you will remember that black cats make wonderful companions. We are loving and loyal, and we will fill your home with happiness.

There are more black cats in the world and that includes feral cats.

It isn't easy being feral and worse, being black. The lucky ones are trapped, neuter/spayed and returned to their colony where volunteers feed them or in the case of Pepper, cared for by a family on their porch. Pepper is cared for by Detti Siklos @detti_bsdfilms

He has a heated nest and regular meals. Some ferals get socialized and transition to indoor life, but ferals in a well managed colony have the same life expectancy as domestic cats.

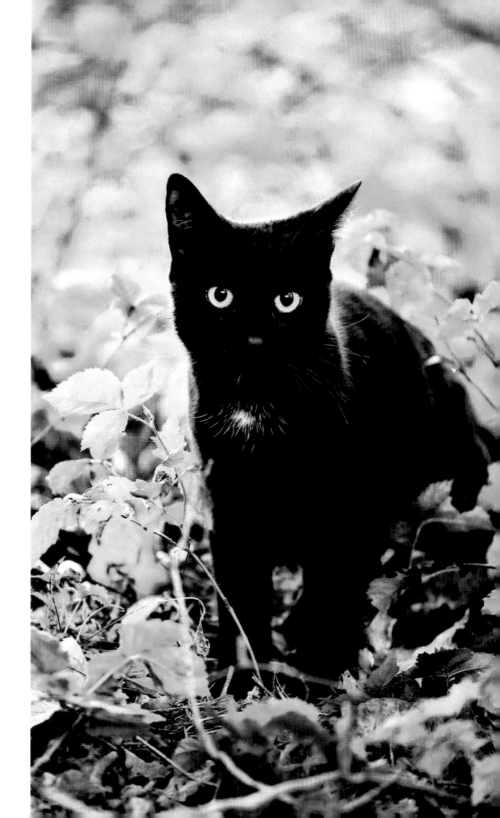

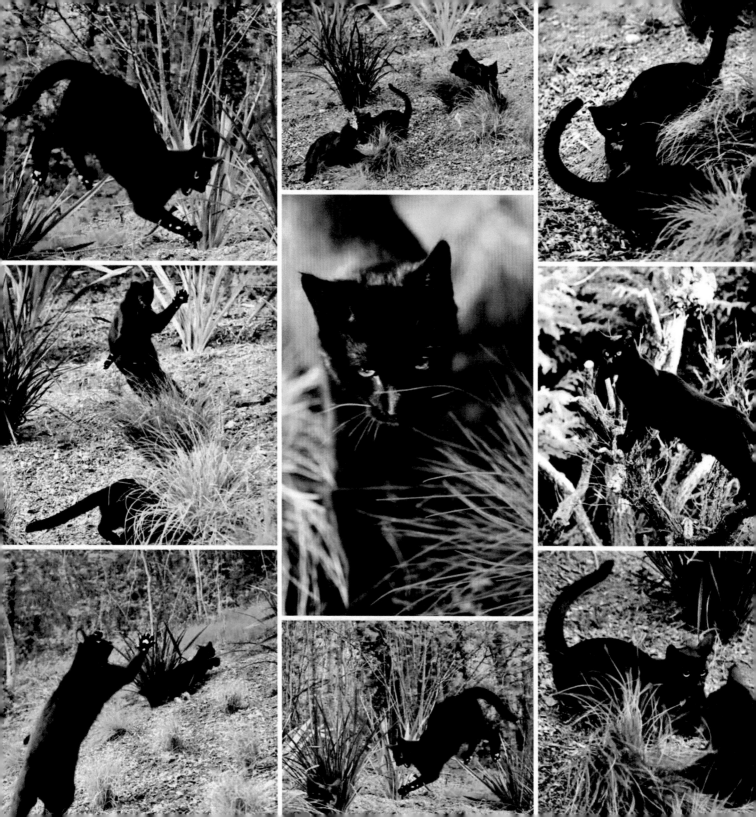

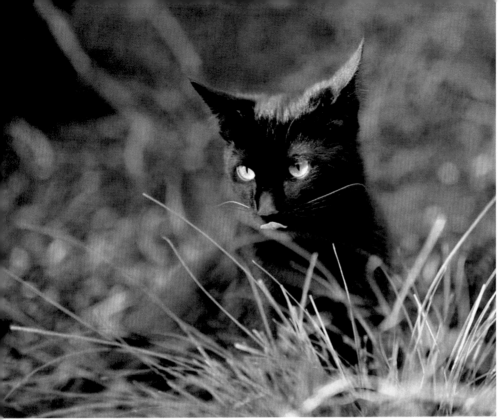

You might think these frolicking cats are feral, but they are not. The three sisters, Frisbee, Boudine and Claudette, plus their cat mom Sasha, live an idyllic indoor outdoor life South West of France.

Instagram
@thelittlecat.diaries

Nala

U.S., Iowa
Nickname: Biggie.
Gender: Female.
Breed: Domestic Shorthair.
Birthday: 10/17/2012.
Gotcha Date: 1/24/2013.
Zodiac sign: Libra.
Weight: 8 lbs.

Any unusual or special characteristics: I love to jump on humans' backs whenever I get a chance. If you're standing next to a counter I'm on, I will put my paws on your shoulders and rub my face against yours. Also very adamant about playing with the toy "Da Bird" and will carry it in at all hours of the day and will meow to play with it.

Occupation: Stay at home cat.

Interests or hobbies: Any and all things bird related, relaxing on the deck, following humans and trying to help them cook, and playing with my sister, Nugget. Hobbies: Playing with "Da Bird,"watching out the windows for any rabbits or birds, and sitting on the shower ledge whenever the humans are in it (because I'm a little weird).

Pet Peeve: Watching the humans cook or eat and not getting to taste test any of it. Being petted without initiating it and ignored requests to play with "Da Bird."

Favorite quote: "Why have one cat when you can have two" – friend Megan M.

Why should people adopt black cats? Black cats are just as loving as any other cat that can be adopted.

What is your idea of purrfect happiness? Relaxing on the deck with "Da Bird," a couple of boxes I can climb into when I want, watching rabbits and birds, and having some delicious turkey jerky.

What is your favorite food or treat? Turkey jerky or whatever the humans are eating.

What is your favorite toy or game? DA BIRD – absolutely cannot get enough of this toy. Will wake up humans to try to play it regardless of what time it is.

If you have any superpower, what would it be? Being able to open the doors whenever I want so I could chase real birds.

Momo

U.S., Oregon
Nickname: Momonator, Goober Man, Kitty Ditty, Dillweed.
Name origin: Named after the flying lemur, Momo, from the film Avatar the
 Last Airbender.
Gender: Male.
Breed: Domestic Shorthair/Bombay Mix.
Birthday: 4/8/14.
Gotcha Date: 8/21/14.
Zodiac sign: Aries.
Weight: 13 lbs. of kitty lovin'.
Any unusual or special characteristics: A white tie on my neck and a white
"panty poof" on my stomach.
Occupation: House Jester and Mischief Maker.
Religion: None.
Interests or hobbies: Going for walks in the neighborhood, picking on my older
 cat brother, Nova, defending my territory from birds and squirrels, waking
 up my humans early in the morning, playing and getting stuck in the
 bathrooms. I like eating food, having my belly rubbed, and chasing Nova.
Pet Peeve: Not getting to go outside for nighttime walks. Dislike lack of food,
 lack of pets, and being chased by Nova.
Favorite quote: "The therapist is in and he poops in a box." – My human.
Why should people adopt black cats? Each one is special and unique, bringing
 innumerable benefits to their humans. Some might even call it luck.
 We're full of personality and life and promise to be by your side whenever
 you need it. We'll guard your sleep, make you laugh, and provide lots of
 purrs to heal your sadness. All we ask in return is a home.
What is your idea of purrfect happiness? Sleeping next to Nova and my humans
 on the couch with a stomach full of food and love.
What is your favorite food or treat? Anything Nova is eating.
What is your favorite toy or game? Chasing Nova, chasing feather and mouse
 teasers, climbing cat towers, and surprise attacking human ankles.

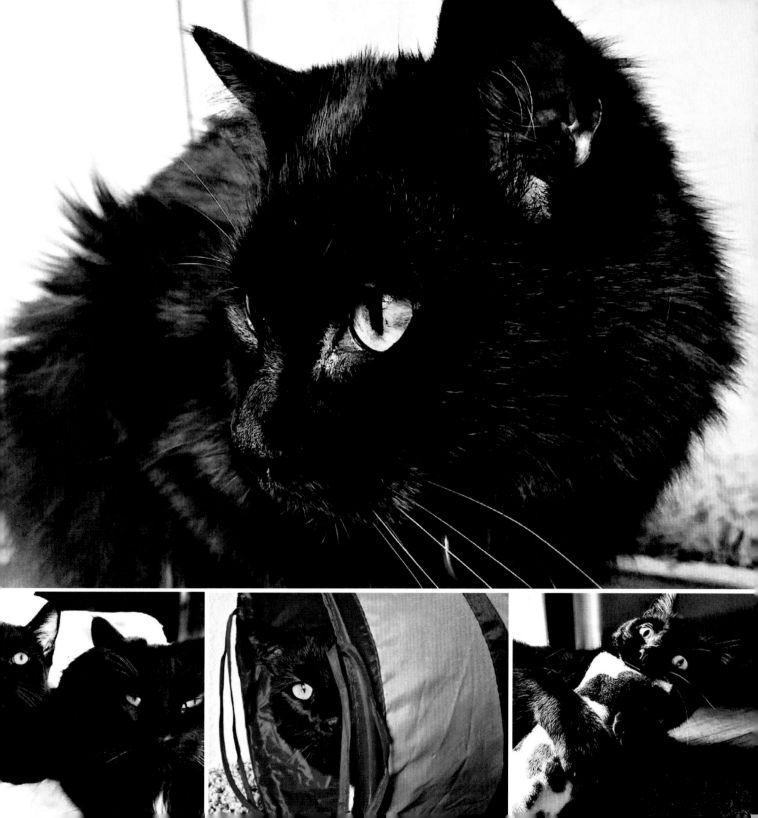

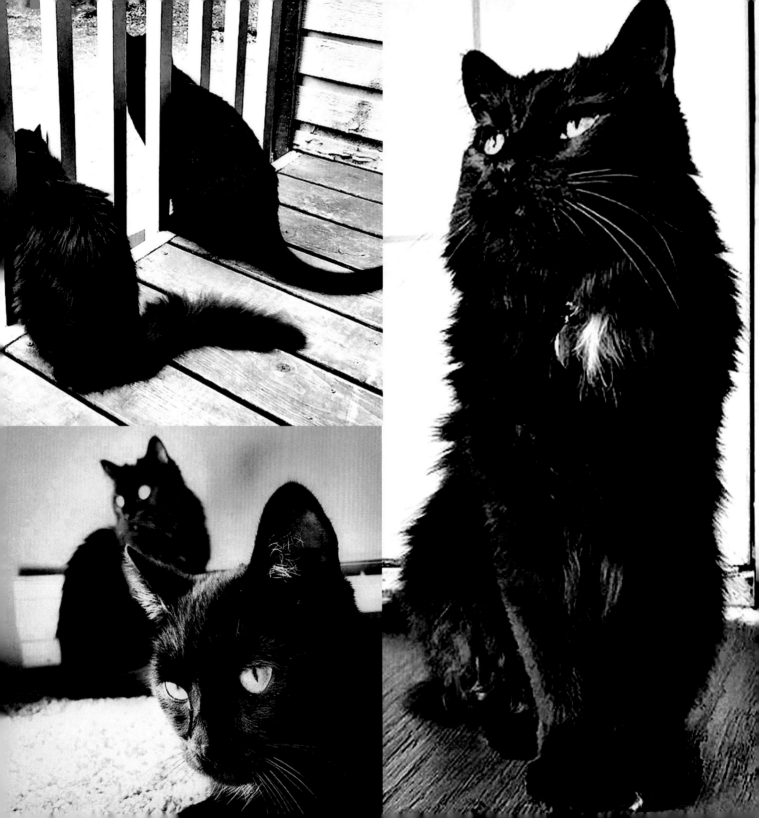

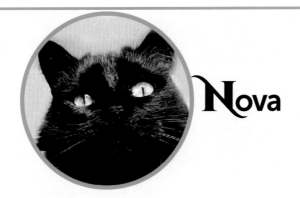

Nova

U.S., Oregon
Nicknames: Novakhin, Novanovs, Hammerpants.
Gender: Male.
Breed: Domestic long hair.
Birthday: June, 2010.
Gotcha Date: August 8, 2010.
Zodiac sign: Gemini.
Weight: 8 lbs. of cat sass.
Any unusual or special characteristics: White fur in between my toes and a gloriously fluffy tail.
Occupation: Emotional support animal and king house panther.
Religion: Self-worship and adoration.
Interests or hobbies: Running through the house, jumping at the walls and meowing at 3 in the morning. Telling off my younger cat brother, Momo. Looking regal and majestic. Like begging for cereal and ice cream, cuddling on warm human feet.
Favorite quote: "What greater gift than the love of a cat?" – Charles Dickens.
Why should people adopt black cats? We're exemplary cats and have lots to offer. Not only do we make excellent friends, we're also pretty great therapists. I know just when my humans need love and never fail to give fluffy, warm cuddles. We're mini-house panthers; we'll protect your home, bring you peace and give the best gift of all, love.
What is your idea of purrfect happiness? Living a peaceful life by the side of my humans.
What is your favorite food or treat? Anything my humans are eating.
What is your favorite toy or game? I really spend a lot of time on my fur so it looks just purrfect. I'm also an avid laser hunter, that dot's got nothing on me.
Social Media: For both Moma & Nova, Instagram @mini.house.panthers

Panther

U.S., New York

Name/Nickname: My full name is Prince Panther de Meowser, but I go by Panther. Although I come from a distinguished royal line, I still cough up hairballs like everyone else and prefer not to put on airs. I have, literally, HUNDREDS of nicknames! My Mom pretty much comes up with a new one every day. A few of the mainstays are: Panthro, Triangle Face Fatback, Lomtick, Meowser Face and Fatty Booboolatty.

Gender: Big, strong and devastatingly handsome male..

Breed: The most excellent Domestic Shorthair! I love being a black DSH and wouldn't change my breed, or color, for anything. In the everlasting words of Lady Gaga, "Just put your paws up cause you were born this way, baby!"

Birthday: Valentine's Day is my birthday (of course!), and I have been with my Mom since I was just a few weeks old. That was four glorious years ago, and I know that I will always be with her no matter what. Most people don't know this, but I'm the first pet (besides fish) she ever had, so our bond is that much more special. "Soulmates" is such a cliché—it's not a big enough word to describe our connection. .

Zodiac sign: Aquarius.

Weight: A husky Adonis of 18 lbs.

Any unusual or special characteristics: Just a mischievous and strikingly fetching guy trying to spread the message about the adoption of cats, especially my fellow black cats.

Occupation: Full time treat, bug, and bird hunter. Unfortunately, I don't get treats very often, because of my rotund circumference. They have to be kept under lock and key or else I will risk life and paw to get at them! I also hold a doctorate in napping and continue to practice that with vigorous zeal every day and night. I always make sure I keep up on all the latest sleeping positions and napping literature written by my distinguished colleagues. In my spare time, I keep an eye on the bathroom so I can supervise and accompany my Mom in there. If she does happen to get the door closed, then I will just howl and scratch at the door the entire time, so it is really easier on the both of us for her to just let me in.

Religion: Love.

Interests or hobbies: I prefer to take a relaxed attitude towards life and take things as they come. Sometimes I will spend the day sleeping on my blanket by the screen door. Other days are spent watching birds either on YouTube or in real life. I also love to be petted, but only on the top half of my body. Shoulder rubs and chin scritches are my favorite, but occasionally I will let Mom pet my belly. Emphasis on "occasionally!" Woe to the human who goes for my belly without my distinct invitation! However, I am overall a lover. I am always wanting to lie on my Mom and give her lots of head butts and sandpaper kisses. I wake her up in this fashion pretty much every day, cause I don't want her to sleep through breakfast time. Meowing at 3 in the morning. Telling off my younger cat brother, Momo. Looking regal and majestic. Like begging for cereal and ice cream,

cuddling on warm human feet.

Pet Peeve: As I am sure is no surprise, my number one pet peeve is humans who disregard black cats simply because of the color of our fur. Other than that, just the normal things bother me, like not receiving my noms on time. Since I'm forever on a diet, I demand that my food be served promptly and that I be petted while I eat my dinner.

Favorite quote: "Happy is the home with at least one cat." – Italian Proverb

Why should people adopt black cats? People should adopt black cats because we are just as wonderful as any other color cat! Unfortunately, old wives' tales and superstitions still plague and associate us with bad luck or evil spirits. THIS COULD NOT BE FURTHER FROM THE TRUTH! Black cats are as loving, playful, funny, and beautiful as any other cat. It is frustrating to see my comrades always be the last (if at all) to get adopted. I should know because I was the last of my litter, and the only black furbaby in the bunch to find a home. People just need to give us a chance, and I promise that if you do adopt a black cat, we will love you and make an indelible mark upon your heart. Anyway, isn't wearing all black always in style?

What is your idea of purrfect happiness? Purrsonally, I'm living the dream! I do whatever I want, I've never missed a meal, and the shoulder rubs are always forthcoming. The only thing that could make it any better is if all my kitty brothers and sisters in shelters could find their wonderful furever homes like I did.

What is your favorite food or treat? As one can see, I am a fan of the noms! My absolute favorite is the cat version of junk food, Temptations Treats! Any flavor is good, but I love the catnip and chicken flavors. I could eat sooooo many! I can hear a bag of Temptations being opened from miles around, I swear! Since I so rarely get to enjoy them, when I do it's like Christmas in my mouth! I really don't like much human food, but I do like Velveeta cheese. Shocking, right? Just the crinkle of the plastic holding those single cheese slices gets my paws racing to the source of that gold. Man, all this talk about food is making my stomach growl! Time to try and pester Mom for a little snicky snack ...

What is your favorite toy or game? I love to play! I have many toys but my favorites are Da Bird and the Cat Dancer. You'd be surprised at how high I can jump! I take down my prey like the Ninja Panther that I was born to be. As much as I like the toys my Mom buys for me, I will probably always prefer what I find around the house, like straws and bits of ribbon or hair ties, over anything from a store. Why, I cannot answer, but it's an almost universal truth with my cat brethren that we prefer crap randomly found around the house to most manufactured cat toys. Oh, and tunnels! I love tunnels too.

If you could have any superpower, what would it be? Who says that I don't already have superpowers?

Social Media: Instagram: @panther_the_black_cat

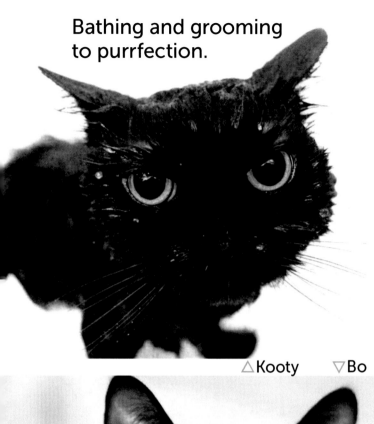

Bathing and grooming to purrfection.

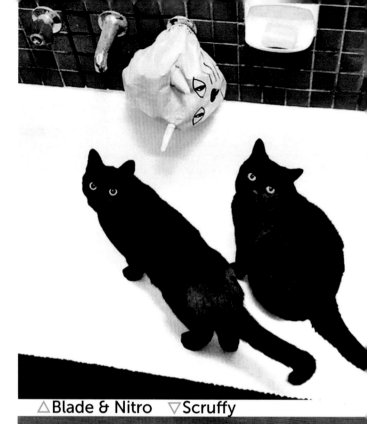

△Kooty ▽Bo

△Blade & Nitro ▽Scruffy

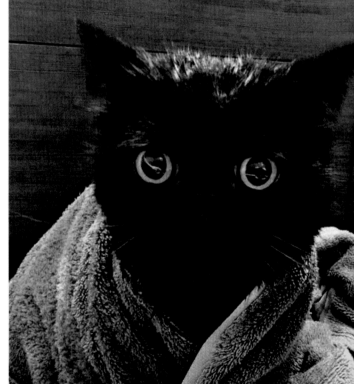

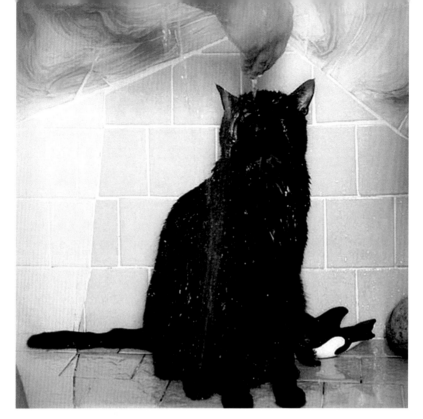

Waterbaby

by Luis

I've always liked water—I like drinking it and putting my foot into it to see the ripples and I enjoy what happens when I slosh some out onto the floor. I'm not one of those cats who cannot bear to get a little wet.

So, one day I was walking by the bathroom shower and one of my humans was splashing around in there, and I just thought—"Why not?" It's a walk-in shower so that is exactly what I did, and from that day on, one of the highlights of my day is taking a morning shower. I like to get really, really wet, and I sometimes will even roll around by the drain. What fun!

Guess it is because I am a Rhode Island cat, and we take this whole Ocean State thing really seriously.

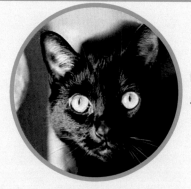

Zena

U.S., California
Nicknames: Z, Beautiful Panther.
Gender: Female.
Breed: American Shorthair.
Birthday & Gotcha Date: April 24, 2013.
Zodiac sign: Aries.
Weight: 11 lbs.
Any unusual or special characteristics: Super sleek and shiny coat.
Occupation: Purrfessional meowdel.
Interests or hobbies: Posing for the camera, wrestling with little sister Shera, doing yoga on the catio and snuggles with HuMom.
Pet Peeve: Water – I head for the hills if one drop accidently touches me.
Favorite quote: "Black cats rock."
Why should people adopt black cats? Black cats are just as loving as any other cat that can be adopted.
What is your idea of purrfect happiness? A quiet Caturday morning while snuggling with HuMom.
What is your favorite food or treat? Holy Cow wet food from the brand "I and Love and You."
What is your favorite toy or game? Da' Bird wand and feather.
What would you choose as your superpower? To be able to catch a hummingbird.
Social Media: Instagram: @Zena_and_Shera

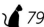

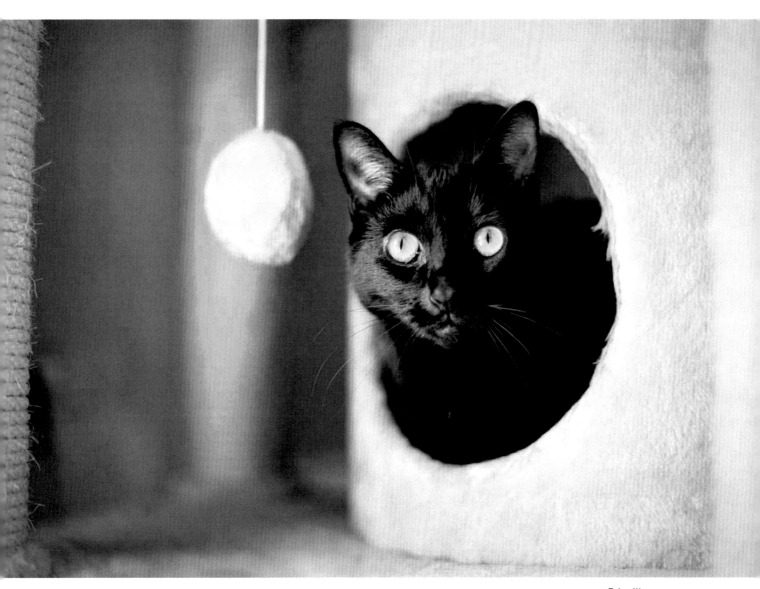

@Ericalikescats

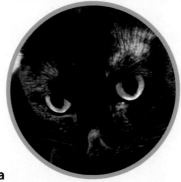

Penelope Kitten

U.S., California
Nicknames: PK, P. Kitty, Baby Boss.
Gender: Female.
Breed: Black American Shorthair and/or Kitty Cat.
Birthday: Unknown.
Gotcha Day: June 10, 2012 from a creepy and dangerous motel parking lot in Los Angeles.
Zodiac sign: Aries – and a true Aries at that. I'm dynamic, assertive, enthusiastic, naïve, and a child at heart – hence the Kitten in Penelope Kitten.
Weight: Not sure, but I can tell ya I'm a biggie big with a bodacious belly/ stupendous stomach/tremendous tummy! Yeah, yeah, I live the good life now!
Any unusual or special characteristics: I don't meow, I squeak.
Occupation: Pesky Kid Sister and Boss of Everyone (human and cat). Blogger and artist's model. Featured in the book *All Black Cats Are Not Alike*, Chronicle Books, 2016.
Religion: Optimism.
Interests or hobbies: My main interest is eating and my hobby is acting cute – supercute. I dislike meanies. I love belly rubs.
Pet Peeve: Closed doors, loud noises and big feet.
Favorite quote: "Be cute, be quirky, be a kitty." That's a quote by me, Penelope Kitten. Also, #blackcatsrule.
Why should people adopt black cats? Black is slimming, which means we can eat all we want. Yum! Black cats are sweet. Black cats are loyal. Black cats are magical and will melt your heart. Black cats look good with your décor. Black cats will stick by you and lift your spirits when you are feeling blue. Black cats will love you forever.
What is your idea of purrfect happiness? Eating, sunspotting, and going for a "walk around" the house in my human's arms.
What is your favorite food or treat? Anything the other cats are eating.
Social Media: Instagram @marcyverymuch

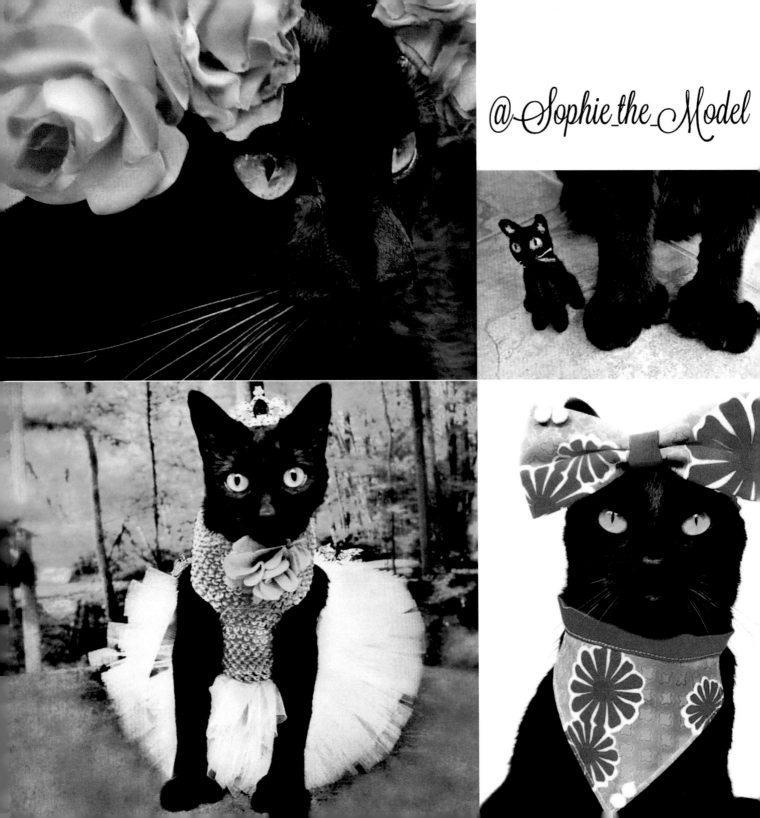

@Sophie_the_Model

Sophie the Model

U.S., New Jersey

Nicknames: Sophie. Sophamia, Stopher, Sophaloaf, Monkey, Monkabunk, Stink Monkey, Stinky Butt, Stinky, Stanky.

Gender: Female.

Breed: I'm ½ Russian Blue, ½ Black, and 100% Awesome!

Birthday: June 1, 2010.

Zodiac sign: Gemini.

Weight: A lady never reveals her true weight.

Any unusual or special characteristics: I'm a polydactyl. I have seven toes on my front paws and five on the back ones. Mom calls them my "Pizza paddles."

Occupation: Meowdel and Ambassador for black cat adoption.

Religion: CATholic.

Interests or hobbies: Of course I love modeling. I enjoy when Mom dresses me up, and I come alive when the camera is on me so I can work my modeling poses. I also love bird watching, bug catching and hunting at night when Mom and Dad go to sleep. I like to catch mice and bring them into the bed with Mom while they're still alive and fresh, which Mom doesn't seem to appreciate.

Pet Peeve: My biggest pet peeve is when I try to play with my cat sister, Polly, and she hisses at me. Polly is a weirdo with some mental issues, so I get it, but come on! Just chill out and play already! I'll tell you what I DON'T like is the D-O-G that lives with us. Even after living with it for a year, I still don't like it!

Favorite quote: "All you need is love.... and a cat." It SHOULD say BLACK cat, but we all need homes, no matter what color we are.

Why should people adopt black cats? People who think that they don't like cats

have never had one, and people who think they don't like black cats, or that we are somehow bad luck, have never had the privilege of having one of us in their lives either. In fact, if you ever speak to a person who has had a black cat, they will tell you that black cats are the most chill, loving and friendly cats they have ever known, and that we bring good luck to them!

My Mom says that her life greatly improved when I joined the family and that I was the best decision she has ever made! Most of the world outside of the US knows that we are good luck and they cherish black cats. The silly superstitions here came from the Salem witch trials, which we all know were bunk, so any human who still believes in these superstitions is just perpetuating those idiotic thoughts! Sometimes humans are just mindless sheep that follow the flock. Don't be mindless sheep, humans! Open your minds and you will see a more beautiful world! Plus, black goes with everything!

What is your idea of purrfect happiness? My purrfect day would consist of Mom constantly telling me that I'm beautiful while she brushes and pets me. I love when she does this when I'm eating, watching birds, modeling or just lying around. I love to be adored during my daily activities!

What is your favorite food or treat? My Mom likes to make me out to be a big foodie, but I'm really not! I hate wet food, I think it's gross, but I do enjoy my grain-free kibble. I don't like ANY human food and don't understand how they can eat any of that stuff, yuck! There are a few dry treats that I like, but not many, and every once in a while, I'll enjoy a couple of chicken-flavored pill pockets, though they make me feel like I have peanut butter on the roof of my mouth and I can't stop sticking out my tongue!

What is your favorite toy or game? My favorite toy has to be the Cat Dancer. It's almost like a moth and I love catching moths, but I get bored with toys pretty quickly. It must be my genius brain or something, but most toys seem juvenile and insulting to me. My favorite toys are real life things.

Social Media: Instagram: @sophie_the_model.

Parsley

*H*ello cat lovers, allow me to introduce myself.

My name is Parsley, but I'm also known as Mr. Sauce, however which sauce depends on the day of the week and this is the current saucy schedule:

Monday - Butterscotch Sauce
Tuesday - Hollandaise Sauce
Wednesday - Parsley
Thursday - Steak Sauce
Friday - Hot Fudge Sauce
Saturday - Sweet Chilli Sauce
Sunday - Mint Sauce

I was adopted in September 2014 after spending far too many months at a local cat rescue, prior to wandering the busy streets for a few months until my untimely incarceration. It all worked out for the best when out of the blue, I was whisked away to a life of unimaginable luxury and love in the English countryside. I am all moggy and proud of it, I have a little white star on my chest but the rest of me is black on black; my fur is silky-soft and gleams in the sunlight, but in the dead of night I'm invisible, like the purredator! At the moment, I'm nearly 4 years old and quite a big boy at 5.6 Kg. [all muscle of course!] and my birthday is 31st August making me a Virgo Kitty.

At the moment I currently work at the BionicBasil Headquarters [BB-HQ] with my fursibs, delivering cat humour, really wild adventures and cuteness on the blog most days of the week. Being a blogger does take up quite a bit of time, however in my spare-time I like to play in the garden and go on field excursions with Basil and Smoochie. I also love snuggles and catnip; fresh, dried or spray, any of the aforementioned equates to purrfect playtime.

I don't have any pet-peeves per se as I'm a rather chilled out kitty and my favourite quote is, "Life is Always Better with Cats" and that brings me to a very important question: Why should people adopt black cats? This is easy, because everyone should have their very own house panther; no home is complete without one, or maybe two. There are countless reasons to adopt a black cat, but I think the main one is because we're all gorgeous and totally irresistible!

My idea of purrfect happiness is being brushed all day and hand-fed fresh tuna while snuggled on the slave human's lap. I'm also quite partial to Dreamies and Luvies and I love the laser toy, chasing the red dot is smashing fun even though it still eludes capture, but one day I'm sure I'll get it!

Summer means time for holidays and adventure.

More cats are traveling with their owners instead of being boarded or left with a cat sitter. The trend for leash-trained cats continues and the very adventurous go hiking, camping, canoeing and kayaking like Ledges @BlackCatTrails.

Cleo

Australia
Nicknames: Peppermint Patty, Peps.
Gender: Female.
Breed: Domestic Shorthair.
Birthday: Unknown.
Gotcha Date: February 2, 2007.
Zodiac sign: Aquarius.
Weight: 5.1 Kg or 11.24 lbs.
Any unusual or special characteristics: I have a tiny white bikini patch, but am no beach babe!
Occupation: Observer of nature and the wilds of the Australian bush.
Religion: Naturist.
Interests or hobbies: Bird watching (a given, really), talking to and following humans as often as I can. Kangaroo stalking and tree climbing.
Favorite quote: "Embrace compassion without exception." – Janice Anderson
Pet Peeve: Not being allowed to go outside at night. That's when all the action happens!
Why should people adopt black cats? Well, why should they not is my answer! Color is such an insignificant thing. If you were blind would color or feel matter more? Does color embrace you in a different way? Such silliness humans come up with – where do they get their ideas? Imagine a world where black cats are universally seen as the beauteous creatures they are!
What is your idea of purrfect happiness? A sunny day, a patch of warm green grass and a view of my world from the top of our property.
What is your favorite food or treat? I must confess I am actually pretty easy-going for a cat. Salmon mousse or fresh meat and yummy kibble.
What is your favorite toy or game? Oh, I love feathers and toy mice and chasing invisible monsters while bent like a horseshoe!
If you could choose any superpower, what would it be? Fly! I want to fly!
Social Media: Instagram @fozziemum

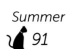

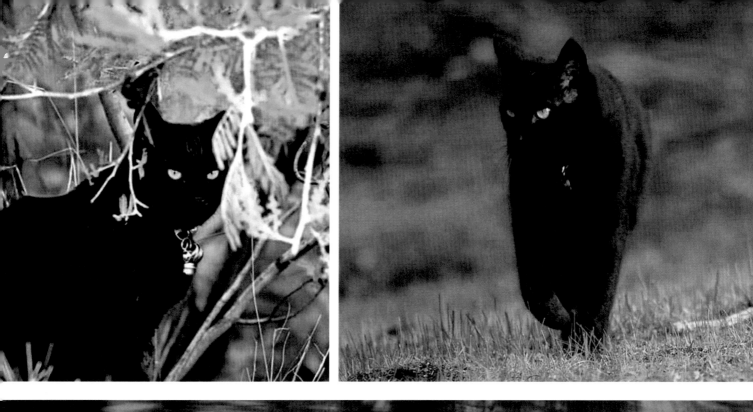

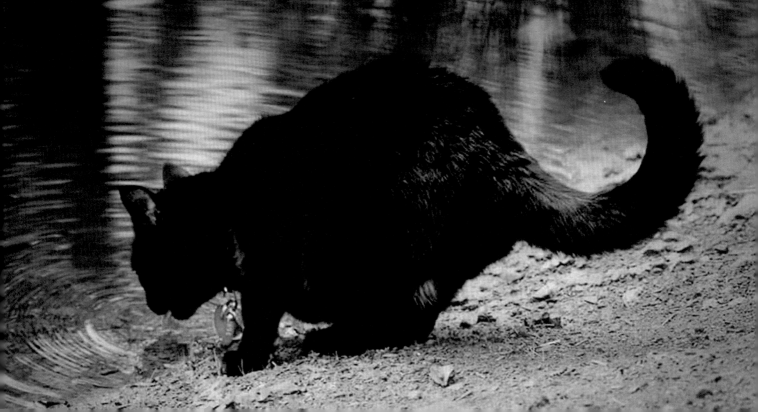

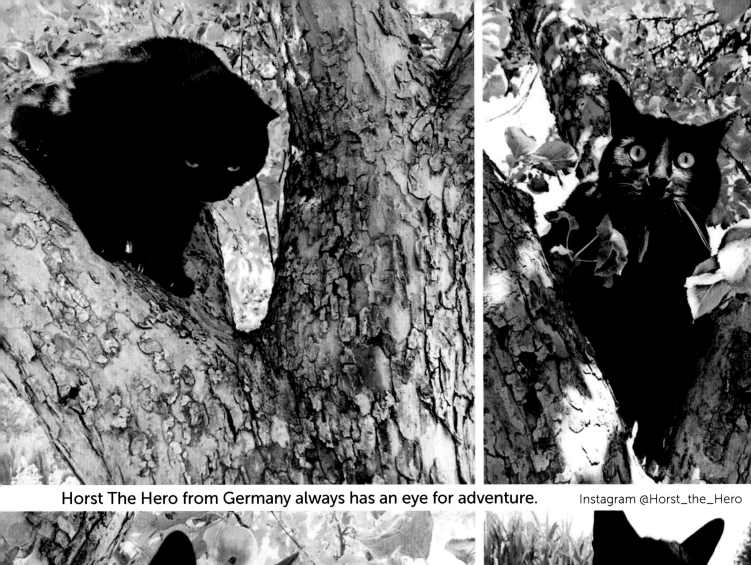

Horst The Hero from Germany always has an eye for adventure.

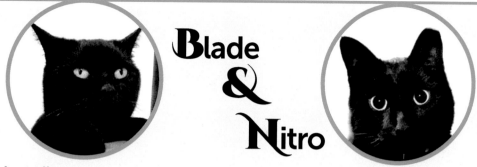

Blade & Nitro

Australia

Nicknames: Blade—Bladey Bum, Mister Mister Man, the Fat One. Nitro—Nitro Man, the skinny one.

Gender: Male.

Breed: British Shorthair (Blade) and Domestic Shorthair (Nitro).

Birthday: Blade—March 11, 2013.

Gotcha Date: Nitro—December 14, 2015.

Weight: Blade—about 5.5 Kilos. Nitro—about 2.5 Kilos. Fat and skinny!

Occupation: Blade is a part-time model, full time ninja. Nitro is crazy.

Religion: CATaholic.

Interests or hobbies: We both enjoy culinary delights, relaxing, and are serious twitchers (bird watchers).

Pet Peeve: Blade—the doorbell wakes me from my slumber and freaks me out. Nitro—Nothing fazes me.

Favorite quote: "Time spent with cats is never wasted."—Sigmund Freud.

What is your idea of purrfect happiness? Good food, warmth and a loving family – and oh, did I mention good food?

What would you choose as your superpower? Telekinesis – then we could open those damned tins of tuna ourselves.

What is your favorite food or treat? Sounds disgusting, but we love raw chicken necks.

What is your favorite toy or game? Mousey mouse on a string.

Why should people adopt black cats? People should adopt black cats because they look like mini panthers, match any type of décor, don't appear to shed hair everywhere (unless you live in a white house – and then you might see it!) look good with everything and are just as loving as other cats.

Social Media: Instagram @blade_the_black_cat

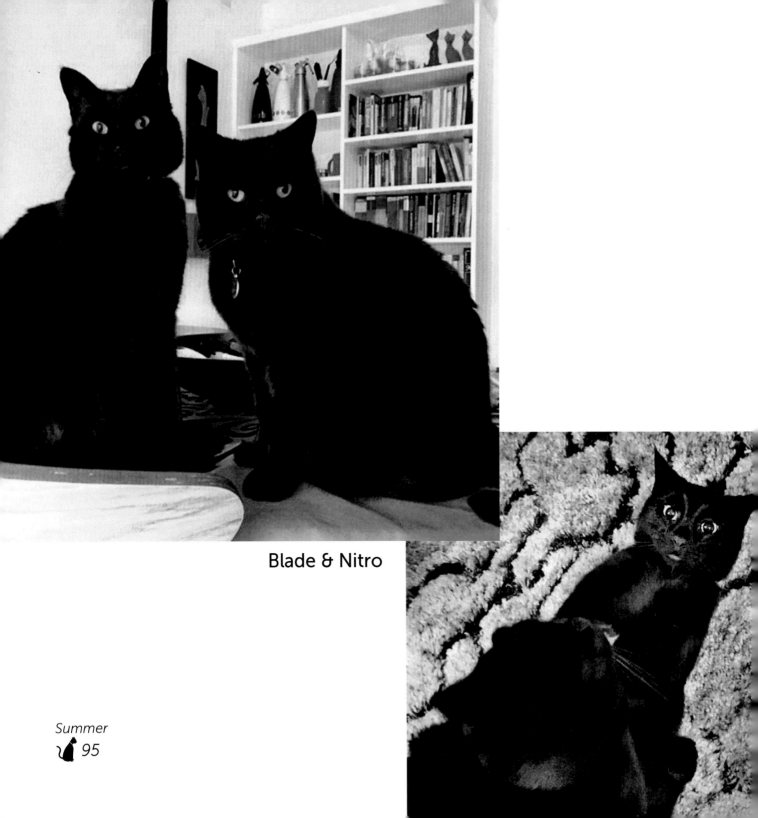

Blade & Nitro

Summer
🐈 95

Merlin the Exotic

Australia
Nicknames: Merlin the Persian, Garden Panther, House Bear.
Gender: Male.
Breed: Exotic Shorthair Persian.
Birthday: August 15, 2009.
Zodiac sign: Leo.
Weight: 4.5 Kg.
Any unusual or special characteristics: Very purrticular, especially with my things. They must be exactly how I like them.
Occupation: Male Meowdel, Catnip Inspector, Chef.
Religion: None.
Interests or hobbies: Pigeons, cooking, catnip, catnapping.
Favorite quote: "You are braver than you believe, stronger than you seem, and smarter than you think." — A.A. Milne
Pet Peeve: Small children touching my stuff & having my photo taken.
Why should people adopt black cats? Black cats are the new black; who doesn't want a mini Panther? Their coats are stunning, they go with everything.
What is your idea of purrfect happiness? Rolling on my catnip plant or hanging with the humans.
What is your favorite food or treat? Turkey!
What is your favorite toy or game? Kill Meowmie?? Can I say that? Okay then, my Mousey.
If you could choose any superpower, what would it be? To deflect any and all devices that take photos.
Social Media: Instagram: @merlin_the_exotic

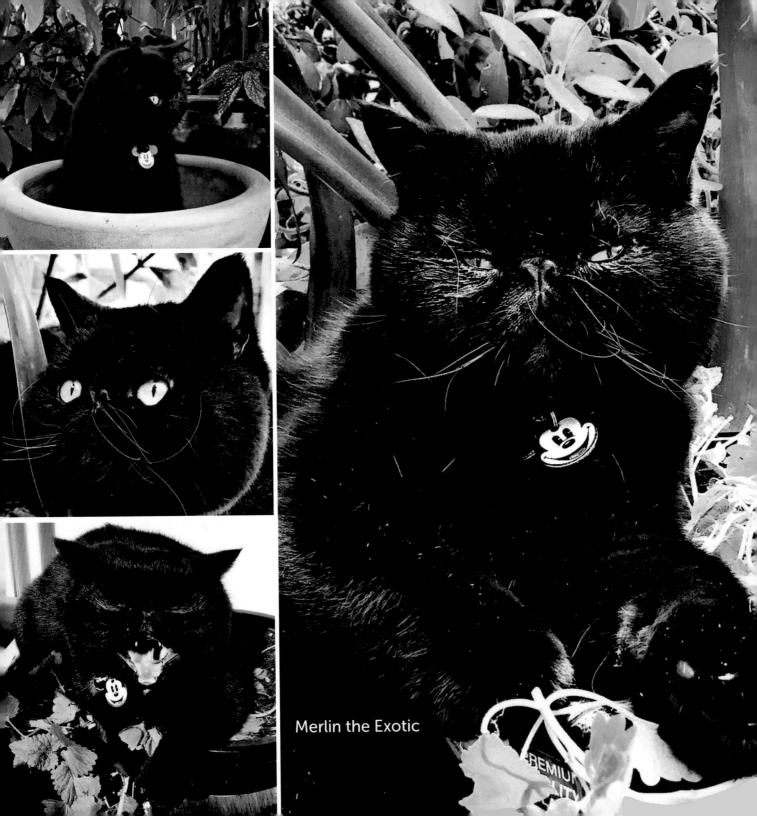

Merlin the Exotic

The Adventures of Willow, The Little Black Cat from Down Under

by Willow, with Richard East

When we are young we are given a sense of how our lives will be lived. We learn day by day everything we need to get along in this world, and we explore it with wide eyes. But sometimes something happens which defies expectation.

The details of how I got there aren't important: you can't always control the decisions other people make for you. But there I found myself at one year old at the rescue centre. Just me. Alone. And 30 other cats. There are many different breeds of cats, but what it comes down to is that there are only two different types of rescue cats. Let's quickly run through them both. Grumpy cat wonders what he did to deserve this. He goes to bed worrying about tomorrow and what it holds for him. Happy cat is grateful for every moment and quickly sees the goodness in others. You might see a part of yourself in each of them.

What most people don't understand about rescue centres is that it is not just the cats that need rescuing, it's also the humans. Each human who comes through those doors has a little piece of their heart that needs mending, and cats, as you might already know, are the best equipped to deal with such a problem.

The day finally came: someone was willing to bring me into their life. His name was Rich.

No one can truly express what it means to a rescue cat to be given a second chance. After many nights lolling in front of the fire next to older brother cat Ty and a tummy full of food, I

must admit, I would sometimes forget. When you are at the top of a mountain it's hard to imagine what it was like at the bottom, and when you are at the bottom of a mountain it's hard to imagine what it will be like at the top. I accepted life day by day.

Some cats are born with the brains, some are not. What big brother cat Ty lacked in intelligence he made up for in fluffiness. Oh boy, was he fluffy. I once spent the good part of an afternoon meowing at a dejected Ty in the corner before realising it was actually a fur ball from a recent brushing session. I miss that cat. I hadn't known Ty for as long as Rich had, but it still hurt when he went Over The Rainbow Bridge. I felt a heavy weight on my chest for many months.

December 22, 2012. Our treasured Ty, lovely Ty.
Fluffier than initially anticipated. Sometimes majestic,
sometimes solemn, usually silly. No match for fast traffic.
Let us hope you catch that red dot and get to drink out of the
bath whenever you damn well feel like it.

Nothing is forever. Even the stars in the night sky will slowly fade away. Or so someone once told me. There is no magic formula for how to deal with the loss of something that means so much to you, only the realization that it is something we each will have to face at some point in our lives. Whether it is the loss of a fellow meow meow, a human, or a relationship, the feelings are very much the same. Sometimes just seeing the hurt others experience is painful enough.

Things had changed at home. Rich hadn't been happy in his relationship for a long time. I softly walked into the living room, navigating between packing boxes and piles of things. I knew things were not right, but I thought they would settle down eventually. However, after seeing box after box being taken away, I realized he was leaving. What about me? Was I to be left alone again? After everything that I had been through, the house was sold and now I had to start over!

With a big smile on his face, Rich pulled into the driveway in his new van. He got out and opened the sliding door. I walked up hesitantly, sniffing the front tire before jumping in. He picked me up, held me above his head and said "This is OUR home now." With a flick of a whisker, my life changed. I was now a traveling adventure cat and we were going to leave our island home of Tasmania and head north.

The next few months I watched as the van was made into a proper home, complete with kitchen, sink, bed, and cupboard – and lots of places to hide. Rich had a mission. He just hadn't quite figured out what it was yet. Travel around Australia with a cat. With no agenda. Sounds sensible. Nothing was certain except our day of departure and current of excitement. It is not easy saying goodbye, especially to those who loved us the most, but Rich waved goodbye and I rode shotgun in the van to the ferry dock in Tasmania. After 12 hours on the car ferry to the mainland, we arrived in Victoria and the vast continent of Australia.

And so we travelled north through the farmlands of Victoria, seeing landscapes flatter than I had seen before, and there were flatter vistas still to come. We would arrive at camp under the towering gum trees wafting their menthol scent. Whilst Rich

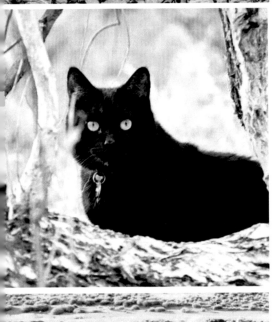

was cooking dinner, I would explore the area, weaving my way through the tussock grasses that lay like a silver velvet blanket across the land. One night I gave Rich a fright. A storm had come in rather quickly and I had to seek shelter under a fallen tree. There I waited through thunder and lightening until morning, when the storm finally passed. I could hear Rich calling for me in a panic all day, but I was in no mood to leave my hiding spot. It wasn't until late that evening that I wandered back to many cuddles and relieved tears. As a result of this adventure, I am now equipped with a satellite positioning device whenever I'm allowed outside.

I must highlight an important point here. A cat is not easily persuaded, nor can a cat be placed, set or positioned. Only a fool would attempt to change the will of a cat. In fact, there is no such thing as a lost cat, only a cat whose notion of where it should be differs from your own. Not all who wander are lost, but some do have their inner GPS malfunction.

It was a month before we made it through the NSW Riverina and over the Great Dividing Range to be greeted with a spectacular coastline of pure white sands and forests that meet the sea. I sniffed the intoxicating scent of woods and salty sea, finding it better than any catnip. Continuing north over the Tropic of Capricorn, we arrived in Cairns, Queensland, and to my surprise headed straight to the jetty. There we hopped into a bright orange dinghy before boarding a 48-foot sailing yacht.

Are cats even meant to sail? I'd heard that sailors and pirates of long ago considered black cats lucky to have on board. Well, this one was about to find out, and we spent three days exploring the Great Barrier Reef. As First Cat on the vessel, I enjoyed the salty breeze and all the attention from other sailors, but to be honest, I prefer having my paws on dry land.

I am often asked what it is like travelling with a human. Well, it is very similar to living with one in that it is very important to set some basic ground rules. These are mine, you are welcome

to use them. Rule #1: There is no such thing as too early, too late, or not now. This relates to cuddles, pats, food or anything a human can provide for you. We run on cat time and cat time only. Human meal times, prior appointments or sleep are irrelevant. Rule #2: The cat is responsible for setting departure times. This can generally be achieved by hiding in bushes. Rule #3: The human's attention is devoted to you and to you only. If anyone else receives more attention than you, this can be resolved by meowing incessantly.

As the seasons changed, we found ourselves contented with our new travelling life. How difficult it was to break free from routine and expectation, to distill one's life down to only the necessities. But on nights sitting around campfires with good company under the freedom of big skies we realize it was worth it.

Our journey continued through the grasslands of Central Queensland, a land so flat that any bump remotely resembling a hill is met with the desire to climb it at once. So often we would stop the van to do as much, to reach the top and gaze over the heat rising from the endless savanna. Across a thousand bumpy miles of gravel road, we made it to the Northern Territory, a land of tall baobab trees sticking out of red dirt and crystal clear streams sprung from desert oases. Entering Western Australia, I watched out the window as we passed emus and feral goats, perfectly at home in such desolate country. Finally, the savanna yielded to the coast, the temperature dropped and we found ourselves in meadows of brightly coloured wildflowers, wondering what our next adventure would be.

Some people travel or move through life knowing exactly where they are going to end up. Some even have a bucket list of things that they need to tick off before their journey ends. For us there is never a destination or goal. Some find themselves far away from home and some find themselves right back where they started. We are still travelling and taking each day as it comes and that's just the way we like it, me and my Dad Rich.

Willow

Australia
Gender: Female.
Breed: Domestic Shorthair.
Birthday: I don't know my birthdate.
 I was adopted in 2011 when I was 1 year old.
Weight: Never ask a lady.
Any unusual or special characteristics: What sets me apart from other cats is that I've been able to explore so many different places around Australia. I'm an adventure cat, an explorer.
Occupation: As a full time travelling, adventure cat. My duties include finding new trees to sharpen my claws on, climbing hills to see where we are and making every camp a home by simply being a cat.
Religion: I see the beauty in everything around us every day.
Interests or hobbies: Exploring, exploring, and more exploring! Dirt baths, finding new hiding spots. Sometimes Rich puts a glow-stick on my collar and I go out and scare other campers, that is great fun. I don't like really big dogs, the smaller ones I can take on no problem!
Favorite quote: "Coax a kitty down with kibble, when home is warm and safe.
 Climbing kitty, up so high, always finds a place.
 No point trying, you'll learn to see,
 For a cat up a tree is exactly where it is meant to be."
Pet Peeve: I really don't appreciate it when it is play time at 3 am and Rich doesn't want to play with me!
Why should people adopt black cats? Deep down inside each of us is an adventure cat, black cats are no exception and so deserve the opportunity to love and be loved, to explore the world like everyone else.
What is your idea of purrfect happiness? I'm a very affectionate cat so my idea of happiness is a full belly, a warm bed to sleep on, and as many cuddles and headbutts as I want.
What is your favorite food or treat? My favourite food above all others may seem strange but like a lot of Australian cats, I really enjoy kangaroo meat.
What is your favorite toy or game? Sometimes I like to teach Rich tricks. His best one is where I stand on a box then jump to another, then he gives me a treat. He's really good at it, silly human.
If you could choose any superpower, what would it be? I'm already pretty good at hide and seek, but maybe invisibility would be fun.
Social Media: Instagram: @vancatmeow

Autumn

Angus

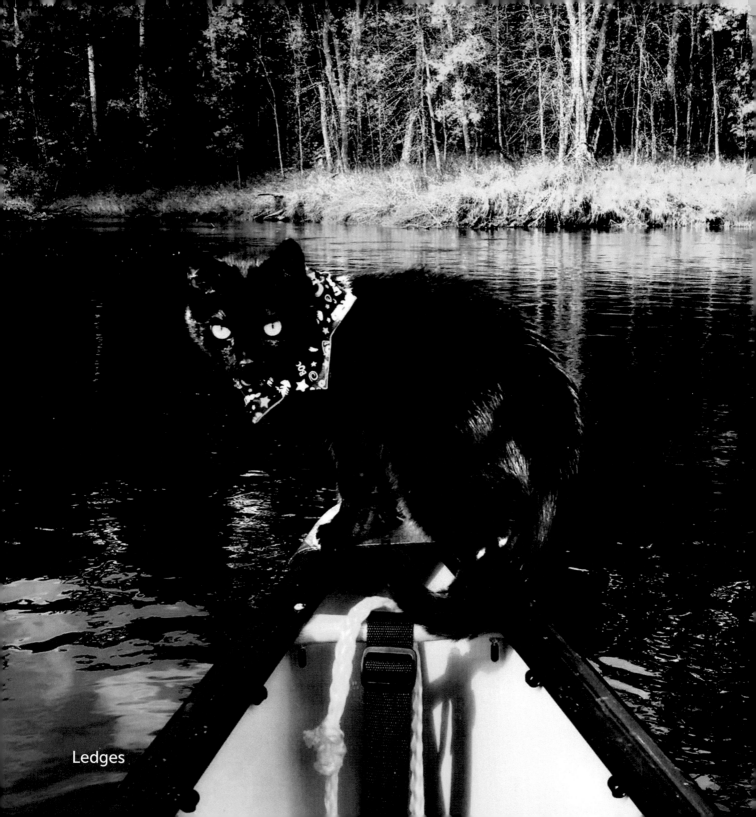

Ledges

Dexter

by Marie Verderame

When we adopted Dexter (full name is Dexter the Serial Killer Kitty) from the Brevard South Animal Care Center, they said he was born in 2007. His owner was a woman in an abuse situation who could not take her two cats to the women's shelter. Dexter's sibling was already adopted.

The shelter was very crowded with cats and the poor guy was in a carrier since no cages were available. My husband was specifically looking for a long-haired black cat so when he saw Dexter he opened the carrier and this adorable black cat walked to the front and licked my husband's nose. The adoption was sealed with a kiss!

Dexter still loves to give us kisses on our noses. Smart too – we did some clicker training with him. He can target my hand, sit, give kisses, beg, lift his paw up (can't call it shaking because he hates his paw to be touched) and stand on his hind legs – reach up and give us a nose bop with his nose. Smart and loving black cats are the best!

Lucky Lola's Journey Home

*by Lola, with Floyd Plymale
and Layla Morgan Wilde*

"For beautiful eyes, look for the good in others;
for beautiful lips, speak only words of kindness;
and for poise, walk with the knowledge
that you are never alone.
Nothing is impossible, the word itself says 'I'm possible'!
The best thing to hold onto in life is each other."

~Audrey Hepburn

If a cat could be a movie star, I would be Audrey Hepburn. I live like a star now, but it wasn't always that way. It took 13 long months before Floyd found me. We both believe everything happens for a reason and nothing is impossible.

I know I'm lucky. Shelter cats, especially those who stay months or even years, are extra grateful to find the right forever home. Finding the right home (or cat) is no easy task. I had no idea what lengths my Floyd went to, such as driving over 300 miles from St. Louis to Indianapolis to meet me. Someone had brought me to the shelter on August 23, 2012, and while some cats adjust to shelter life, I did not. Even the best shelters are no substitute for a real home. I sulked in my cage, miserable and forlorn. The good folks at the shelter let me out of the cage, and I became something of an "office cat". There were no offers to adopt me. More misery arrived in the form of a serious upper respiratory infection that lingered for months. Finally, I was put in a foster home, which helped me heal. Foster homes are temporary, but I didn't know that. Once I was healed, wham, I was back at the shelter and not a happy camper. I hated landing in the shelter again.

So, one day I'm brought into the adoption meet and greet room, in no mood to meet anyone. I may look like a diva, but I'm really not. The shelter did not bring out my good side. I hid underneath a bench and hissed at Floyd. He claims my funny-sounding hiss was adorable. I later found out he'd come to meet some other cats and really took this adoption thing seriously.

He had two criteria: 1) he and the cat should click and get along but more importantly 2) the cat should choose him and not the other way around. Too many people show up at shelters with expectations of what they think they want. It could be about age, size, color, breed or whatever instead of being open to the right cat for them. The "right cat" could be the one they least expect.

Floyd started his online search for a cat months earlier. After a move from the town he'd lived in his entire life for a new job, he thought his new home felt empty. I could have told him a house is not a home without a cat, but this was before I had my own Facebook page. On a Facebook group, he explored various rescue groups and shelters. One shelter had a page where they'd featured me and another black cat named Abe. We were in foster homes at the time and Floyd felt a connection. He thought maybe he'd like to adopt both of us.

Sadly, Abe needed surgery and then the sadder news: he had cancer and was placed in hospice care. Even though Abe was no longer available for adoption, Floyd eventually decided to make the long drive to meet him and me. Abe could have been my brother, but it wasn't meant to be. I don't really get along with other cats: in that way, too, I'm a diva. Floyd met a few other cats and considered adopting another pair, but it didn't feel right. What felt right was when he extended his hand towards me and I licked him. With my "kitty kiss," I let him know he was "the one." The one and only one.

For someone who had never adopted a cat before, my cat dad learned fast. It was more complicated because he didn't live in town. Luckily, the great folks at Hamilton Humane agreed to keep me in foster care for three weeks so my new dad could prepare my new home and buy everything the luckiest cat in the world would need.

My official Gotcha Day arrived on a beautiful sunny afternoon at the of end of September. Hamilton Humane volunteers, Christine and Traci, generously agreed to drive me halfway from Indianapolis for the exchange. Lots of cats hate driving in cars, but I don't mind as long as I'm in my trusty old carrier. It's the one I used as a bed in the shelter office and remains a favorite snooze spot to this day.

A few hours later, we arrived at my new home. Usually, it's good idea to introduce a new cat to its new home gradually. The cat stays for a few days in one room before moving to the rest of the house. But since there were no other pets or people to meet, I couldn't wait to explore my new digs or should I say my new diva domain. Mine, mine, all mine! My already doting cat dad had put out food and water and let me explore every nook and cranny of our two-story home. He was tired from the exhausting day and went upstairs for a nap. Naturally, I was curious about the comfy king-size bed. In a shelter, cats don't get the chance to snuggle and sleep with humans, so I wasted no time and quietly jumped onto the bed. Nice. Warm body. Nicer. He woke up to me purring, snuggled up against him. Some people don't like cats to sleep with them and even lock them out of the bedroom. I was thrilled to find out I could sleep anywhere I wanted. After all, it all belongs to me, including Daddy's heart.

Is this a happily ever after story? The shelter director said I'd hit the adoption jackpot. My Dad tells me I changed his life. Since adopting me, he's become involved in many animal charities, met new cat-lover friends and continues to learn about the animal shelter process and making a difference. He

realized shelter animals have feelings and know the absence of love and belonging.

And me? Cats live in the moment, and some of us can let go of the past more easily. I hold no grudges for my year living in the shelter system. It could have been a lot worse. The odds of an adult black cat with health and behavior issues being adopted are slim to none. I count myself very lucky and grateful for a second chance.

I'm naturally sweet, but my confidence has soared. When anyone visits, I am a gracious and kind hostess. My extended human family adores me, and I have a soft spot for my grandma. I love traveling to my grandma's for long weekends, Thanksgiving and Christmas holidays, where I'm the center of attention and renowned for bestowing kitty kisses. Yes, I sit on chairs like a human and I love to lick, but woe to anyone who touches my belly.

At home, I've grown more talkative. I respond to my name, chitter at birds outside and my Dad says I have an indescribably cute sound which means "hey". You might say I've come into my own, as cats do when they're allowed to feel safe, respected and loved. And being a diva, I don't mind getting dressed up on occasion, pearls and all. As Audrey Hepburn would say, "The beauty of a woman is seen in her eyes, because that is the doorway to her heart, the place where love resides. I believe in being strong when everything seems to be going wrong. I believe that happy girls are the prettiest girls. I believe that tomorrow is another day, and I believe in miracles."

I am a very pretty girl. And I believe in miracles, because that's what my adoption was to me!

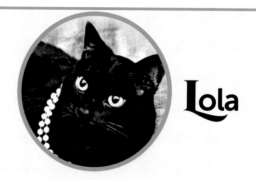

Lola

U.S., Missouri
Nickname: Nicknamed "Lo Poo" by her Grandma.
Gender: Female.
Breed: Domestic Shorthair.
Birthday: We celebrate her Birthday on 8/23, that's actually the day her old family gave her up at the shelter. Try to make that a happy day. The day she came home from Foster Care was 9/28/13.
Zodiac sign: Virgo.
Weight: 13 lbs.
Any unusual or special characteristics: Loves to sleep in her carrier, loves people, loves to lick and love bite.
Occupation: Office Cat... she is always "in her office" during the week, while I'm at work.
Interests or hobbies: She loves looking out the window at the birdies, sleeping and just show affection to those she loves.
Pet Peeve: Don't rub my belly.
Favorite quote: "Sorry I can't hear you over the sound of how awesome I am." —Lola. I don't know why, but I could see Lola saying that.
Why should people adopt black cats? Black cats are the most overlooked animal in the entire shelter system, give them a chance and no only change a cat's life, but change a person's too.
What is your idea of purrfect happiness? Treats, Sunshine, Grandma's house.
What is your favorite food or treat? Friskies Party Mix.
What is your favorite toy or game? I love my catnip mousies, that my friend Joan sent me, and my blankets.
Facebook: https://www.facebook.com/Lola-632836356735776/

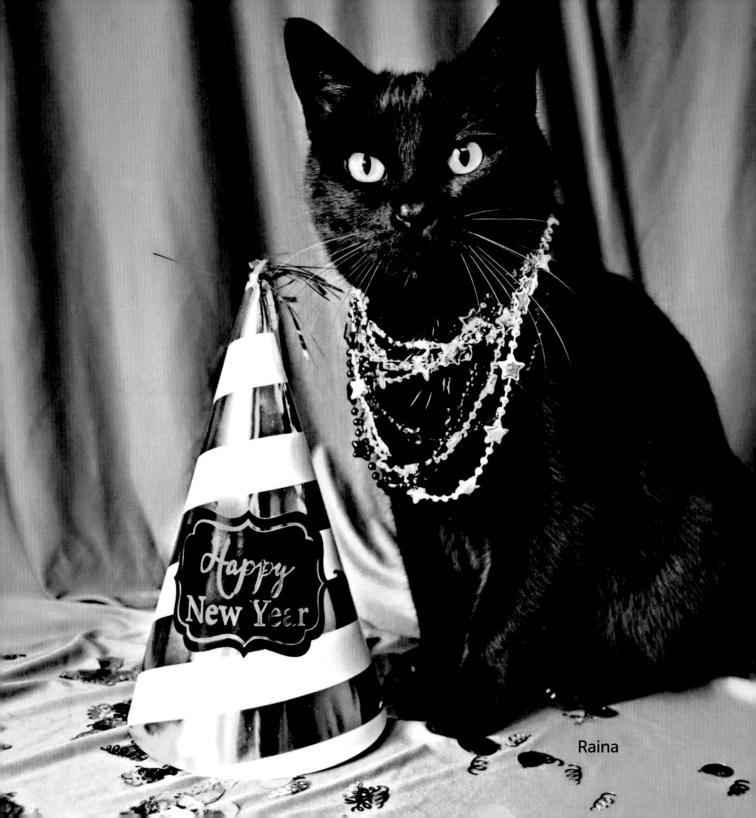

Raina

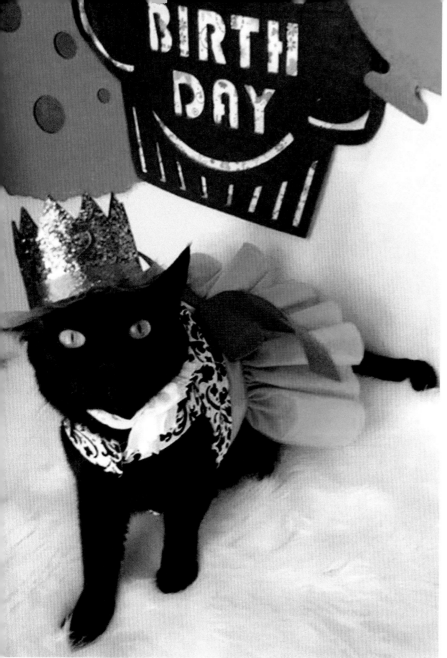

Most of the black cats I know **celebrate** all the holidays their pawrents do. Their cats are an acknowledged and beloved part of the family. From simple to elaborate "pawties", they celebrate their birthdays like Toothless and/or Gotcha Day, the lucky day they adopted their black cats. Blue (upper right) is celebrating Valentine's Day while Cooper (lower right) is celebrating Shark Week.

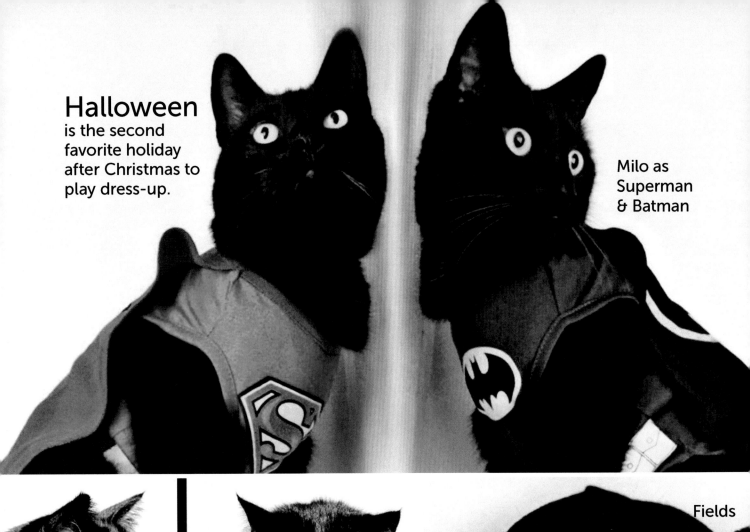

Halloween is the second favorite holiday after Christmas to play dress-up.

Milo as Superman & Batman

AC

745711
11 14 09
MIL WI

Fields

△ Papa ▽ Milo

too CUT to SPOOK

Ledges

Bronte

A house
is more
magical
with a
black cat.

Echo

U.S., Michigan
Nicknames: Mr. Krabs, Old Blue Eyes.
Gender: Male.
Breed: Domestic Shorthair.
Birthday: Unknown.
Gotcha Day: March 10, 2003 (around six weeks old).
Zodiac sign: Not a stargazer.
Weight: 18 lbs.
Any unusual or special characteristics: Very patient.
Occupation: Big Brother and Boss of Chase, Dexter, and Lyric, Mom's BFF.
Religion: None.
Interests or hobbies: Soaking up the sun and following Mom from room to room. I like noms, boxes, licking plastic, sleeping next to Mom.
Pet Peeves: Vacuums and brooms. Mom saying she has to vacuum! Or... she has to play Pawparazzi.
Favorite quote: "Let's go to bed." – Mom.
Why should people adopt black cats? Because we're awesome!
What is your idea of purrfect happiness? ALL homeless kitties would have a home!
What is your favorite food or treat? Friskies Party Mix.
What is your favorite toy or game? My green kicker toy or hair ties!
Social Media: Instagram @four_spoiled_brothers

Echo

Ernie

U.S., Michigan
Name: My name is Ernie, but my rapper name is Easy E.
Gender: Male.
Breed: Domestic Shorthair.
Birthday: Unknown.
Gotcha Day: March 11, 2006.
Zodiac sign: Unknown.
Weight: About 12 lbs.
Special characteristics: I'm a polydactyl, which means I have extra toes.
I have 7 toes on each of my front paws and 5 on each of my back ones.
Religion: Unknown.
Pet Peeves: The fact that people are afraid of black cats and are reluctant
to adopt them because of silly superstitions. Black cats are wonderful!
Why should people adopt black cats? People should adopt black cats because
we are very friendly, good looking and we go with everything! You
know what? I found my home because I was black. That's right! When
my Mom was looking for a new cat to adopt, she read how black cats
were considered to be less adoptable and were often overlooked in
shelters. She knew right then and there she had to adopt a black cat.
So she started searching on Petfinder.com for black cats in shelters
near where she lived. And she found me. And y'know what else
convinced her I was the one? I'm a polydactyl. I have extra toes, and
my mom thought that was pretty cool and made me even
more special.
What is your favorite food or treat? I love freeze-dried chicken treats!
What is your favorite toy or game? I love wand toys!!
Social Media: Instagram: @theislandcats

Leopold

Smoky's Thanksgiving Story

by Smoky,

with Maureen Calloway Carnevale

Here is my adoption story. It is simple and sad. On Thanksgiving of 2007 my daddy noticed me in the street while putting out the trash. I was wearing a collar, but no tag. My current family wasn't sure if I belonged to someone or not, since they were new to the neighborhood. All they had to feed me was turkey. It was smoked turkey. This is why my name is "Smoky." Also because my fur is black like smoke.

My new family continued to care for me and bought cat food. I slept outside wherever I could find a warm place. The Monday after Thanksgiving, my parents had to go back to work and worried about me all day. They posted a "found" sign on the community bulletin board and when one neighbor said she was willing to take me in, my parents got very indignant. They didn't post to find me a home: they wanted to make sure I didn't belong to anyone and was genuinely lost.

About a month later, a neighbor confessed to seeing an SUV drive up to the cul-de-sac on my street, open the door, dump me out, close the door and drive away. On hearing that, my new parents "officially" adopted me right then and there. I was taken to the vet and given a full checkup. Turns out I was healthy, had already been spayed and was about a year old.

I am the sweetest cat, with excellent manners. I will never know why I was abandoned or why my ex-family didn't surrender me to a no-kill shelter. But I am thankful for my new family, and every year, my parents celebrate my birthday on Thanksgiving.

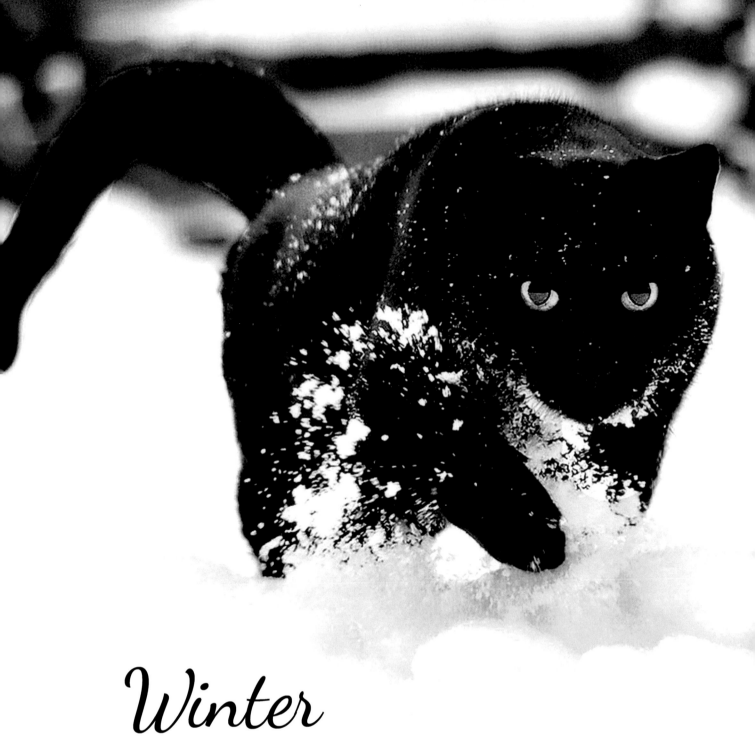

Winter

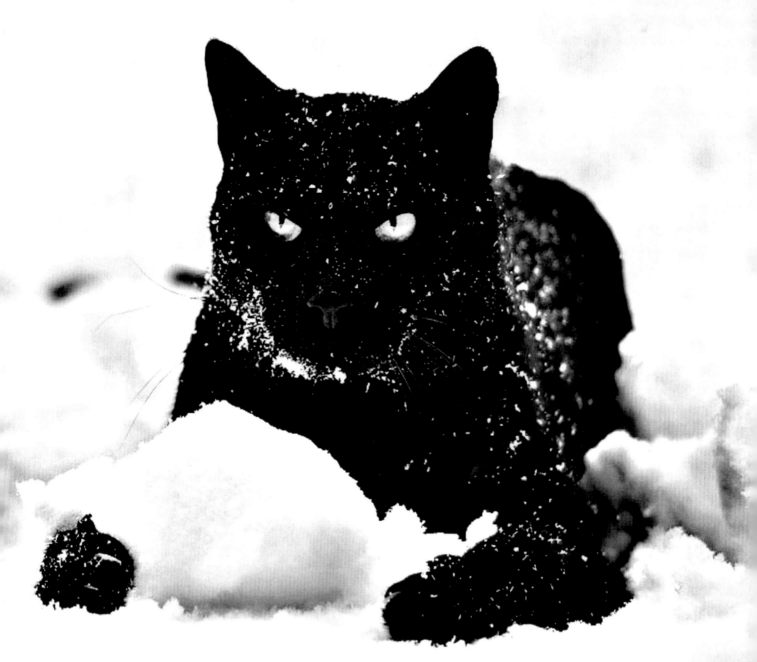

Rufus, Germany

From Frostbite To Warm Love
by Rosie, with Kristin Avery

Buddy, the old grey feral, told me that if I ever needed help I should find the yard with the yellow garage and the broken gate. He was a survivor and knew all the ins and outs: best garbage cans, hiding places, kindest humans in the neighborhood.

I tried to make it on my own, but I was so hungry and tired. When my legs grew weak and my insides ached and I felt like I couldn't go on, I remembered Buddy's advice and found the yard with the yellow garage. I curled up in the bushes and waited. Finally, a little girl appeared with a plate of food. I was so hungry that I came right out of hiding and gobbled it down.

The next day the little girl brought a lady with her and pointed to my crinkled, scarred ears. The lady made a sad face and said, "The poor baby is all skin and bones." She told the little girl that my ears might be related to malnutrition and would hopefully perk back up with some steady food and a healthy diet. But I knew they would not.

The next day they put my food in a green box with holes in the side. I walked right in and started eating and didn't notice when they closed the door behind me. They brought me inside from the cold to a magical room with a couch, rugs, pillows, and lots of food and water. When they opened the door of the box, I came right out and started exploring. I even rubbed up against the lady and the girl, though I didn't like being picked up and gave a few hisses when the lady tried.

There was another human in the house, but I didn't meet him right away. He was sick with the flu when I arrived, and by

the time he was well, I had made myself right at home. The big guy suggested they didn't need a fourth cat, but I was already curled up tight like a donut on the couch and clearly not going anywhere.

The lady believed that I had lived inside at some point. She suspected I had been abandoned or maybe lost. She walked around the neighborhood looking for lost cat signs, but there weren't any. Sadly, no one was looking for me. My memory is hazy but she's right, I had belonged to someone and was not a feral like Buddy.

A few days later, I was loaded back into the green box and brought to the veterinarian. The vet was very nice and gentle with me. He thought I was around a year or maybe a little younger. He also discovered I was missing several teeth and thought that my ears were a result of frostbite.

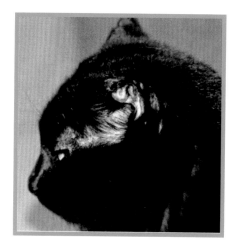

The vet was right. My ears were damaged during a bitter winter storm. I was just a kitten and new to the streets. I chased some snowflakes and my fur became wet. The temperatures dropped suddenly and the tips of my ears froze. Buddy told me later that outside cats must always keep their paws, ears and tails dry to avoid the pain of winter's bite. I learned that lesson too late.

The lady volunteered at a shelter for homeless cats and told the girl that my chances of adoption were slim. She said there were already many black cats there waiting patiently for homes. Sadly, a black cat with missing teeth and scarred ears would not be super-adoptable. I knew deep down that the lady had fallen for me and that's the real reason she adopted me – no matter what she said.

It turns out the lady has a blog, which mostly features my rescue dog sister Ruby. I would like to be on the blog more and sometimes even photo-bomb Ruby. Unfortunately, when I

From Frostbite to Warm Love

 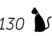

appear on the blog people often leave nasty comments about my appearance. One person even wrote, "Ewwwwww, what's wrong with her!"

Anonymous comments aren't the only problem. Sometimes friends of the little girl say I look scary and mean and don't want to come into our house if I'm in my usual spot on the chair near the front door. And in the week before Halloween, the lady keeps me in the bedroom upstairs when she is not home. Black cats are often the victims of cruel pranks around Halloween, and she worries that I might be vulnerable in the living room window.

Honestly, I don't understand what all the fuss is about. I have the most beautiful, shiny, soft black fur you can imagine and gorgeous, expressive green eyes. And while I do have some unique features, they give me character. For example, because of my missing teeth the tip of my tongue often hangs out, which always sends the humans into all kinds of crazy giggling.

I'm also friendly and love everyone – cats, dogs, kids, and even rabbits. I can be a bit bossy (I call it being assertive) and have on occasion hopped up on the dining room table and helped myself to the little girl's dinner. She's a picky eater and I am not. I'm extremely generous and loving and now help care for my senior feline sister, Elsie, who is currently in hospice care. Sometimes, I even humor Ruby by napping with her on the couch.

My feral friend Buddy continued to live in the neighborhood and returned to our yard for food and visits. The lady built him a shelter where he lived in the winter, but he always wandered during the summer. Sadly, late one summer, he returned badly injured. Although he never wanted much to do with humans, he finally allowed himself to be trapped. The lady brought him immediately to the vet, but it was too late and he

passed away peacefully.

I am pretty sure Buddy knew I wasn't cut out for life on the streets and so he sent me to the right yard where I would find my happy ending. And I did; I only wish Buddy had, too.

I got my fairytale ending. But many black cats do not. They are the least likely to get adopted, and they suffer the highest rates of euthanasia. This needs to change NOW. Please see us as we are — loving, loyal, playful, affectionate, beautiful, extraordinary, LUCKY house panthers!

Rosie

U.S., Michigan
Nicknames: Miss Rosie, Rosie Posie.
Gender: Female.
Breed: Domestic Shorthair.
Birthday: Unknown.
Gotcha Day: July 5, 2009.
Zodiac sign: Leo!
Weight: 11 lbs.
Any unusual or special characteristics: Two missing front teeth and ears scarred from frostbite.
Occupation: Leader of the household.
Religion: Karma.
Interests or hobbies: Sunny windows, boxing for treats, and jumping on the table during dinner parties.
Pet Peeves: Having my nails trimmed.
Favorite quote:
"Just like moons and like suns, With the certainty of tides, Just like hopes springing high, Still I'll rise."– Maya Angelou
What is your idea of purrfect happiness? A full belly, a sunny window, and a warm lap.
What is your favorite food or treat? Scraps of turkey and salmon.
What is your favorite toy or game? Boxing for treats.
Why should people adopt black cats? Because black cats are feline fabulous – beautiful, sleek, elegant, playful, graceful, loving companions!
Website: www.thedailypip.com

Don't box me in.
If I fit, I sit.

Wilmoth

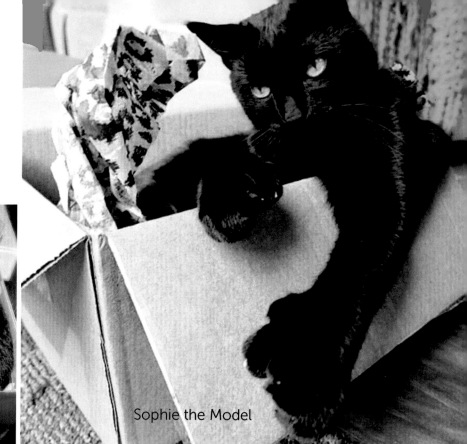
Sophie the Model

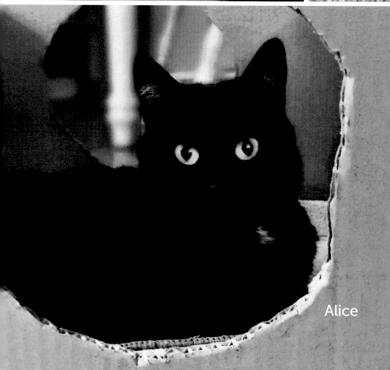
Alice

AC

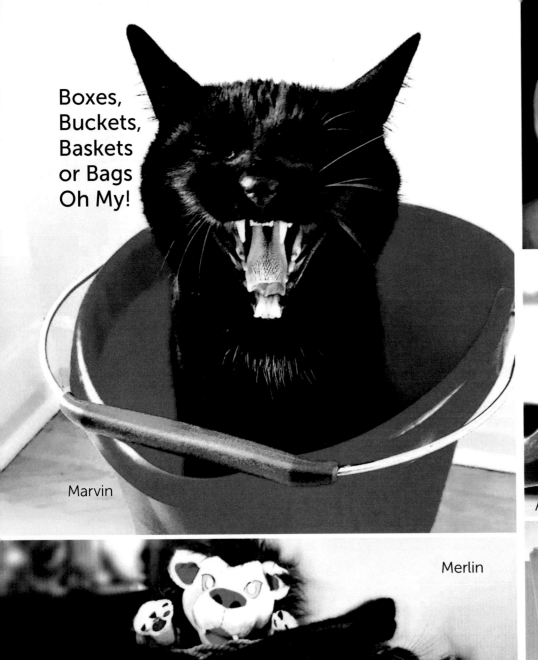

Boxes,
Buckets,
Baskets
or Bags
Oh My!

Marvin

Gag

Alice

Merlin

Blade the Black Cat

The Legend of Black Lightning, the Crime-Fighting Cat

by Shalom, with Chris Hudson

Let's go back to that moment in time when everything changed. It was a day just like any other day. I could feel the fresh spring breeze blowing on my whiskers. I was standing in a litter box pondering what to do with the rest of the day. Suddenly crack bam POW! A lightning bolt struck the house. The litter box quivered and I felt something tingle. I wasn't sure what had happened.

My fur felt all tingly, but everything seemed fine and it was time to start the day. I had a long list of things I needed to do, play with that feather, sit on my mama, talk to the birds and spy on the squirrels. I walked into the kitchen looking for that awesome feather, and I saw my sister Push Push. "Hey, Push Push, how is it going?" She mewed and her eyes squeezed shut.

"What's the matter?"

"Ow, Shalom, I'm just beside myself with sadness and worry. It's all gone terribly wrong. I don't know what happened to it, where could it be?"

"Where could what be? Push Push! What's gone?"

"I just don't know where it is."

"Push Push, WHERE WHAT IS?"

"My catnip-encrusted diamond necklace. It's gone! I went to put it on this morning and look at myself in the mirror, as I sometimes like to do, and it wasn't in its box." Sobbing, she said, "Shalom, you have to help me find it. I have looked everywhere! It's a priceless family heirloom!" She got that look in her eyes when she really means business. For a second I thought she might whack me. (She's the queen, don't mess with her.) She said, "I need my catnip-encrusted diamond

necklace, Shalom, and I need it now!"

"Okay, okay, I can try and help you look for it." Buzz buzz, it's that sound and that funny feeling again. BUZZZzz

"What is that noise?" says Push Push.

"I'm not sure, but I feel kind of tingly."

"Your fur does look kind of funny. Are you OK?"

"Yeah, I think so." Slowly the sound and the tingling start to fade. I said, "What we need to do is an investigation. I've seen them do it on TV. Don't worry, Push Push, I got it covered. First thing I'm going to do is question all the suspects."

"Suspects?"

"Yeah, there have to be suspects if there's a crime."

"Who are you going to question?"

"Well, the only suspects in the house of course, Monkey and Baby Jesus. I think I'll start with Monkey. Where is he?

"I think he's in his cube."

Buzz buzz. It's that weird noise and tingling feeling again. Where is that sound coming from? I stop and decide I need to look around, ponder things a bit, maybe take a little cat nap.

I still feel kind of funny, but I press on. I am a serious investigator now. I start walking, then jogging, and then running up the stairs. Buzz buzz, here is that buzzing sound again and it gets louder and louder. My fur gets more and more tingly, everything around me slows down, but I'm going faster and faster. What's happening to me? I run as fast as I can, trying to see if I can escape the buzzing. Then I realize the buzzing is coming from me! It's all I can hear. and my fur stands straight up in the air.

Woaahh! I am going back in time! I feel once again the lightning crash and a bright flash of light and the tingling sensation. That cracking noise was the sound of the lightning hitting the house. Somehow the power of the lightning strike must've gone into me through the litter box. (It's a magic box where our pee and poo disappears.) In that moment, I became Black Lightning, the crime-fighting, time-traveling cat!

Now I can really help Push Push, fight crime and find her catnip-encrusted diamond necklace. I decide at that moment I must keep my powers secret, so my double life begins.

Where is that Monkey? I wander into the next room and there he is, just as Push Push said, sitting in his cube. "Hey, Monkey."

"Hey, Shalom."

"How's it going?"

"Mighty fine," he says.

"Did you hear the loud buzzing noise?"

"Buzzing noise? No, maybe you had too much catnip last night."

"Oh, okay then, maybe it was something in my dream. I have a few questions for you, Monkey."

"Questions? About what?"

"Where were you last night between the hours of 9:00 PM and 9:00 AM?"

"Let me think about it. First I was downstairs sitting in the window, spying on the squirrels. You know I think they are planning a revolt. We are going to have to watch them."

"Yes, I think you're right. But back to what you were doing."

"Yes, first was squirrel watch, then I had a little snack, and then I went in the laundry room and slept on some clean clothes. After, I had a little play with my catnip fish. Finally I came up here and fell asleep in my cube. I think that's it."

"Can anybody testify as to your whereabouts? Can anybody back up your story?"

"Well, Shalom, you can."

"Me?"

"Yeah, don't you remember? You came and sat next to me by the window. Then you followed me into the laundry room and knocked me off the pile of clothes."

"Oh, yeah, that was so funny, I remember that."

"Then when I came upstairs to sleep you jumped on my head."

"Oh, yeah, that was even funnier than the laundry, hee-hee. But that was at 10:30. What about between then and 9:00 AM?"

"Once you finally left me alone, I stayed in my cube and slept the rest of the night."

"Okay, maybe I believe you. Sounds like something you would do, sleep for 10 hours."

"We are cats, Shalom, sleep is our thing."

"Yeah, okay. Thanks for answering my questions. Let's watch the squirrels again later," I say as I walk away.

There is only one way to find out if Monkey was sleeping all night. It's time for Black Lightning. I walk, run, and then buzz, bam,

paw, and tingle. I am transformed into Black Lightning and am going back in time. I stand in front of Monkey's cube and watch time slowly ticking. At 10:30 I see myself jumping on his head (still so funny) then at 11:00, 12:00, 3:00, 9:00 AM. Monkey is still sleeping. I stop moving, and everything returns to normal. I guess he was telling the truth. Always liked that Monkey. Honest guy he is and a champion squirrel watcher.

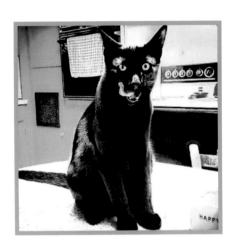

That leaves only one suspect left, Baby Jesus, my tuxie furbro. I have a look around upstairs and check all of Baby's favorite places, the sink, bathtub, closets, beds, and nope, not there. He must be downstairs. He does like to hang out in the kitchen (who doesn't?), so I find him sitting on his favorite chair.

"Hey Baby, what's up?"

"Not much, just living the dream, can't complain."

"Baby, I have a few questions for you. Where were you last night between the hours of 9 PM and 9 AM?"

"Umm, let me think about that. I do have a very tight schedule. At 9 PM I was sitting on the kitchen counter waiting for the humans to feed us. At 9:30 I was sitting in front of humans, waiting for them to feed us some more. After that, I found some awesome laundry that was clean on the floor and took a little nap. Then I ... think ...Then I sat in the window. After that, I came back to my chair and slept there the rest of the night."

"Can anybody corroborate this timeline?" I ask.

"Well, you can, Shalom."

"Me?"

"You don't remember? At precisely 9:15 you jumped on my head while I was sitting in the window. Then again at 10:15 when I was sleeping on the laundry. Finally, when I moved to my chair, you swatted at my tail for 10 minutes."

"Oh, yeah, I remember now. Good times! What about after 10:30? I didn't see you after that."

"I was sleeping in this chair like I said."

It's funny. Baby seems nervous, and normally he is one cool cat. I take a step forward, give Baby a closer look, and take good long sniff. I smell catnip! I look at his paws and can see sparkling green catnip diamonds.

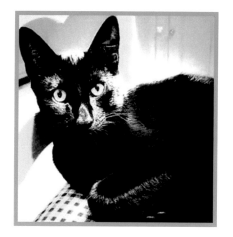

"Baby, is that catnip diamond on your paws?"

"I don't know what you're talking about," he says, wriggling in his chair.

"I can see it from here, Baby, and I can smell it from a mile away. Baby, where did you get that catnip?"

"I may have left out a few small details of my evening. I may have played with Monkey's catnip fish after I slept on the laundry. Then maybe I played with Push Push's catnip-encrusted diamond necklace."

"So it was you! You took her necklace! Baby, where is it?"

"Honest to God, Shalom, I just played with it. Maybe I pranced around in it a bit just for fun. It does look fabulous on me. You know that Push Push never lets anyone play with it, and that's not fair. So sometimes when she is sleeping, which is often, I take it out and play with it. She's my sister, and I would never steal anything from her. I just played with it and put it back. I have no idea where it is."

This Baby is one tough customer. I move in closer and look him straight in the eye. I say, "Baby, did you take that necklace?"

"No!"

I walk away. There is only one way to find out if he took that

necklace. It's time for Black Lightning! I start to walk, then run, and tingle poof bam I am moving back in time. I can see Baby sleeping on the laundry and then see him playing with the necklace. He is prancing around (I should have brought my camera). Finally he puts it back into the box and goes to sleep on his chair.

I stop and come back to normal time. So it really wasn't Baby: he was telling the truth. Who was it? I'm stumped. This crime fighting is harder than it looks on TV. It wasn't Monkey, it wasn't Baby Jesus and I know it wasn't me. I need to ponder this for a little while and decide it's time for a little catnap.

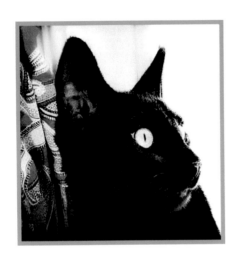

After a few minutes, OK maybe more than a few, I am up and focusing on the investigation. It wasn't Monkey or Baby Jesus. Who does that leave but Push Push? I know she's one smart cookie, and I have no time to waste. So I transform into Black Lightning! Pow, tingle, bam, and I am watching Push Push last night. She is snacking, sleeping, snacking, munching, rolling, snacking and then she's wearing her necklace. She's looking at herself in the mirror (vain creature that she is), and she puts it back in the box. Then she goes to sleep and comes back and puts the necklace back on for the second time. It does look fabulous on her. After a few minutes, instead of putting it back in the box she decides to go for another snack. With the necklace on. She finds a bag of potato chips and sticks her whole head into the bag. Several minutes later, she comes out of the bag, covered in crumbs. I stop running and return to normal time.

I have solved the mystery! I run to the kitchen, open the cupboard, find the bag of potato chips, and there it is, the necklace and few potato chip crumbs. I take the necklace and start to yell to Push Push, but she is, of course, already sitting behind me, having heard the crinkle of the potato chip bag.

"My necklace! You found it! How did you know it was in that bag?"

"That's the power of good detective work ," I say. And a little help from Black Lightning. "Next time please be more careful, Push

Push, sticking your head inside a potato chip bag could be dangerous."

That's how it all started, and how I became Black Lightning.

What adventures will I discover next? How far back in time will I go? You'll just have to stay tuned and see if you can keep up with me, Black Lightning, the world's fastest crime-fighting cat.

Shalom

U.S., Vermont
Nickname: Black Lightning, Monster, Shalomykins, Tukus.
Gender: Male.
Breed: Unknown.
Birthday: 10/31/2015–Halloween!
Zodiac sign: Scorpio.
Weight: 12 lbs.
Occupation: House taste tester and all around handsome man cat.
Religion: Mama.
Interests or hobbies: Food, Mama, sleeping, licking, playing with his bro Monkey, licking stuff & solving crime. Telling tall stories and catnip cultivation.
Pet Peeve: Loud feet, small portions.
Favorite quote: "Meow like the Dude." – Shalom
Social Media: Instagram @crazycatladyceramics

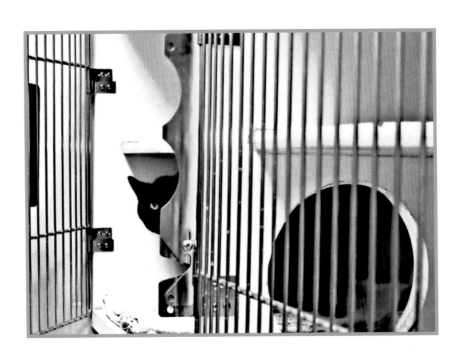

The Catnip Made Me Do It

by Inky Von Inkvon, with Layla Morgan Wilde

There's no excuse for bad behavior unless of course you're a cat. By some ancient decree, all cats are exempt and blameless for any act of naughtiness, hijinks, prevarication and even the murder of creatures who squeak and tweet. Cats are in cahoots together, globally. We know the truth collectively. The problem is that the humans, who allegedly run the planet, did not get the memo: cats can get away with murder.

Okay, some of you get it. You look the other way when we bring furry sushi as gifts. You are easily trained to open cans of food on cue, scoop our poop and leave baskets of hot out-of-the-dryer laundry as spa treatments. We rub up against you, and like Pavlov's dog, you respond with pats, scritches and belly rubs. The really well-trained human would rather go catatonic than move a muscle if a cat is happily snuggled up against them. If that sounds like you, this story is far too subversive. It may force you to question your beliefs or your ability to separate fact from fake news. I would suggest you stop reading.

Go on, log on to your favorite online shopping outlet and purchase your cat's favorite treats, catnip and new toys. While you're at it, buy a few cat books, and don't forget to treat yourself to a kitty t-shirt or other feline item that supports a cause like Black Cats Tell All.

Are you still here? That darn curiosity got the better of you. That's what happens if you live with cats long enough. Our habits and sensibilities rub off. Our wisdom too. My apologies for getting you here under false pretenses. The title: "The Catnip Made Me Do It" was a ruse, a smelly red herring to lure you in, like trapping feral cats with KFC chicken or sardines. You see, dear reader, I'm a cat who discovered a way to time travel and I don't need to get

high on catnip to go on a trip.

 It begins with a sad ending. Many moons ago, say 5 and ¾ lives ago, I showed up at a home that had three kids. The youngest, a blonde-haired girl fell in love instantly with my tiny black fluff ball and huge squeak. The girl, let's call her L., had a picture book of kittens and one of them was called Smokey, so that became my name. Not terribly original, but what do you expect? This was before Google, where thousands of cat names pop up with a click of a mouse. Besides she was too young to read. She couldn't do more than cry when her parents gave me away to stranger

down the street and my fate was sealed. After much begging, the parents took her to my new home. A dark, musty basement full cobwebs and sorrow. I was no longer a cherished pet, but a lowly mouser. For one last time she held me in her arms and promised, no matter what, we would be together again. Little did I know it would take several lifetimes.

My mouser life was cruel and short. My next one wasn't much better and even shorter. At least when the car slammed into me, I bounced straight into my next life. Finally, a real home with a warm bed and regular meals. I can't tell you how much I appreciated meal time without picking through garbage cans. A residue of memory filters from one life to the next. Cats may live in the moment but we never forget. A trust broken, stays broken.

While I zigzagged across time and space, my human soulmate, Miss L. grew up and found cats everywhere. You know the type. Anywhere, anytime when you least expect it. Cats hear the siren call and come running. Our kind. Purr. Head butt. Mew. She adopted all kinds, but hoped one day to find me.

It didn't stop her from loving other cats and did, by the dozen. One cat, Inky, stole her heart and many years later when he died, she mourned the loss by getting a tattoo. On her left inner wrist, a fancy skeleton key was inked by a top New York tattoo artist who skillfully added the details without questioning why. At the top of the key, strange symbols snaked along the edge. On the corresponding spot on her right inner wrist, an ornate Victorian keyhole swirled in symbols with the silhouette of a black cat in the center. She didn't tell the artist her secret. Inky had whispered to her before he died, "I carry your heart and you carry mine, from the deep roots of life to the infinite sky. Broken is the same as open. After the ink has healed for one moon, place your left wrist next the right and the iron is transmuted to gold. Say the incantation and the portal will open. You will be able to find the next fur body of my soul. As I so will it, it is so."

Magic is never that simple. It took practice and a lot of

The Catnip Made Me Do It

wrist-rubbing, but one day the portal opened and she found me. The only problem was I had some unfinished business with my owner. It meant waiting, but I'd pop through the portal every full moon for an astral visit. It's not as snuggly warm as the real thing, but the next best thing to psychic Skyping.

One day, the planets aligned and I popped by with a message. Watch for signs online and in the sky. The crows cawed at daybreak and an email notification pinged about a cat needing a home.

Excited at first, Miss L. skimmed the lines and clicked on the image. Her heart sank. She squinted at the screen. "He's so old, sixteen. How could he be my Inky Von Inkvon? And what kind of old fogey name is Clyde?"

Humans can be so dense. It took another early morning message from the crows. This time, they left a large, inky feather on her front doorstep. She picked it up with a smile and called the shelter.

Oh, the gods have a bizarre sense of humor when it comes to cats. They always send the cat you need, which may or may not be the one you want. And so dear reader, now you know the secret of how I arrived in my ninth life and home of the editor of this book. We no longer need portals or incantations and sleep fur to skin, heart to heart. The tattoos have mysteriously vanished. Perhaps they were never actually there. Perhaps they will reappear one day. I've revealed enough for now. Cats are cagey with their secrets. It's how we keep you on your toes.

I will share one more secret. If you adopt an inky shelter cat, ask if they'd like a new name. They usually do unless you know their real name. Layla has grown to love the name Clyde. After all, Clyde, Inky and Smokey are all branches from the same tree. The same tree that has joined cats with their beloveds for thousands of years.

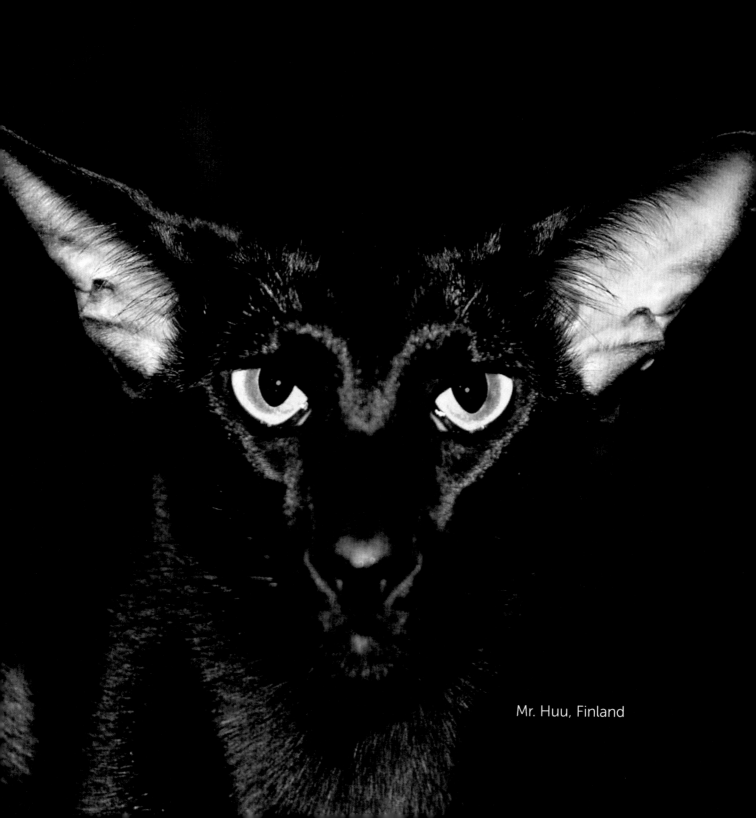
Mr. Huu, Finland

Kat's Black Cat Club
by Kat McCann

I'm often asked why I only adopt the black cats. I usually say the same thing: "Because they are the best cats." Actually, that is not quite true. It is because they choose to adopt me. We are drawn together. True, when I look to adopt, I usually look for the black kitties, because they are the hardest to get adopted. Shelters have more black cats than any other color. Other black cats have just shown up for me, as if to say, "We heard black cats are welcome here."

Mojeaux

I have had guardianship over 11 black cats, and I will tell you – hands down they are the most loyal, the easiest to train, the sweetest, most gentle, quirkiest, most mischievous, independent, smartest, most loving, and beautiful cats! And they are! All of that and more!

Wait, what's that you say? That sounds just like your beloved cat? Fluffy and Rex are just as smart, loving, etc.? I agree with you. That is because black cats are really NO different than any other cat. The difference is in perception, and I am out to change how one perceives not just the cat in general, but the black cat in particular.

I have had many friends who have told me that until they met my cats, they truly did have a prejudice against them. I feel good when they acknowledge that I have changed the way they view not only cats, but black cats. I feel even better when they go to a shelter and adopt a cat. I do a happy dance when they adopt a black cat.

I knew my husband, Dennis, was the right man for me when my cats approved of him. Kizzie, my shy Hurricane Katrina Rescue, came out to greet him. GrisGris, my protector cat, sat right next to Dennis on the couch, and purred – LOUDLY! GrisGris is OTRB now, but Kizzie sleeps on Dennis's shoulder.

Together, we have adopted five more – Jockamo, Feenanay, Mojeaux, and GiGi. We call them our Black Cat Club! We made provisions in our will for the cats we will have in the future, who will probably be black. Our future looks black – full of black cats, that is!

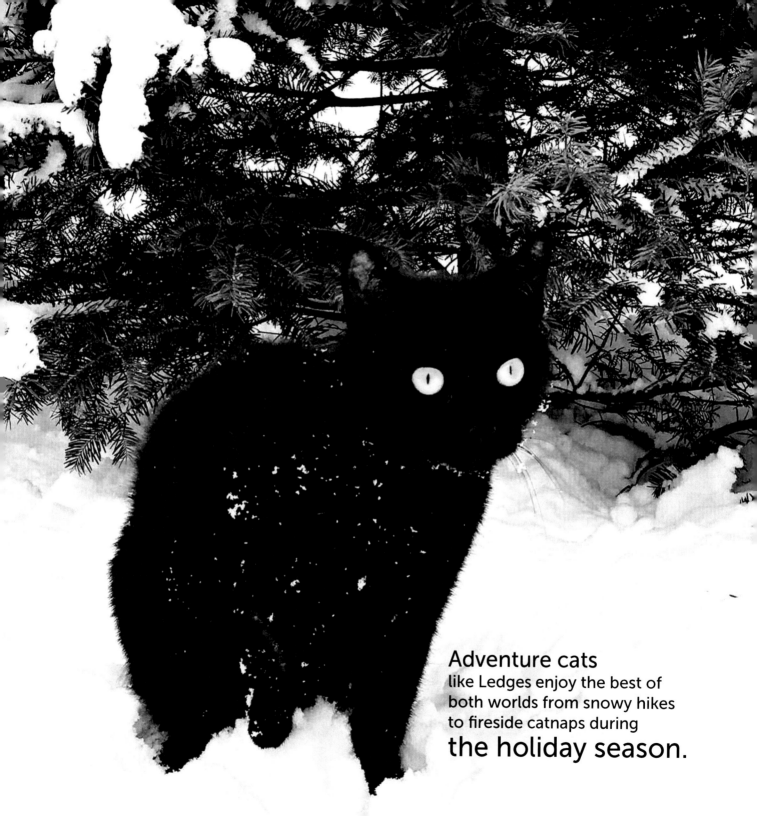

Adventure cats
like Ledges enjoy the best of
both worlds from snowy hikes
to fireside catnaps during
the holiday season.

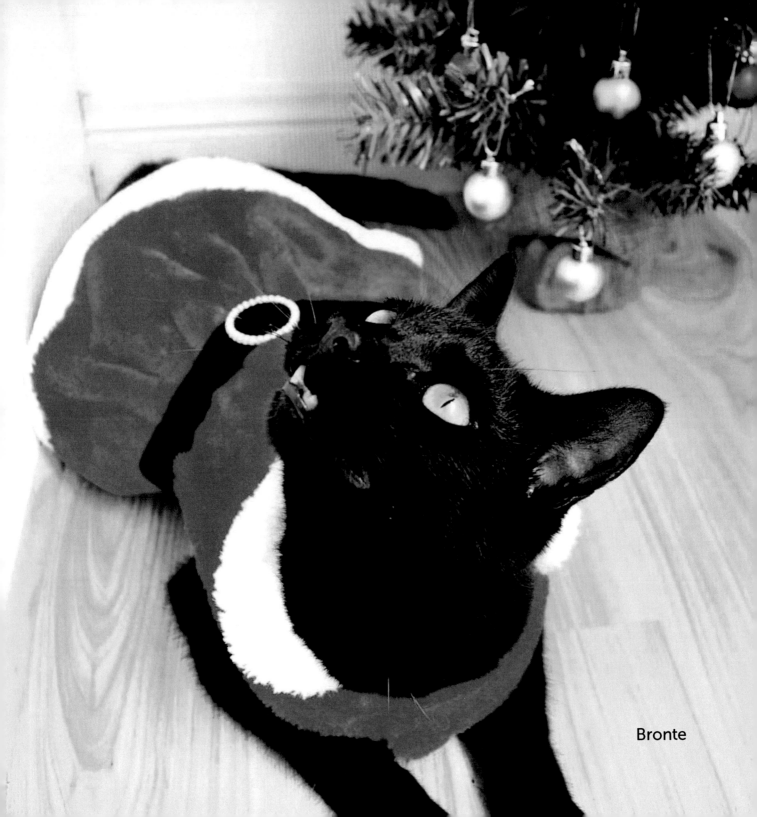

Bronte

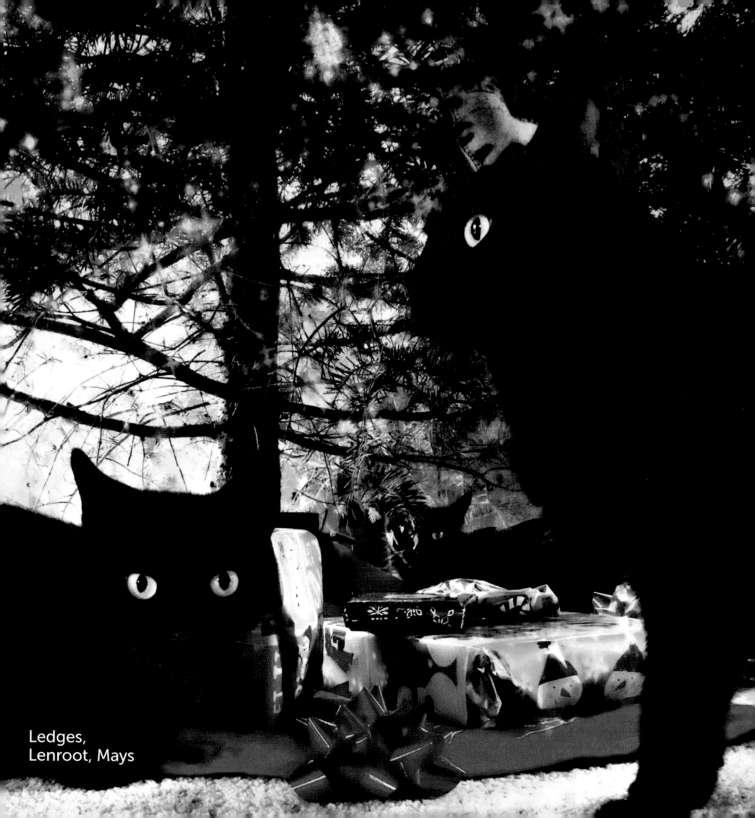

Ledges,
Lenroot, Mays

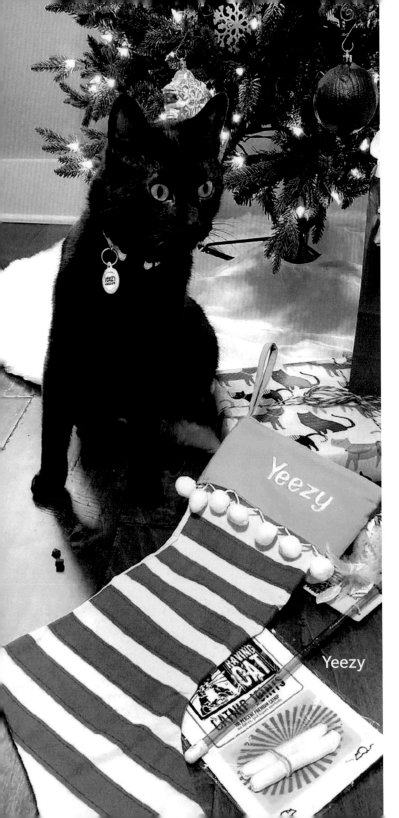

Yeezy

△ Clyde ▽ Merlin

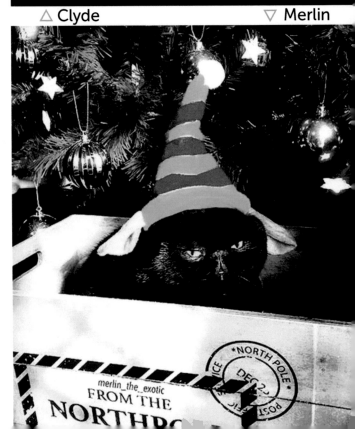

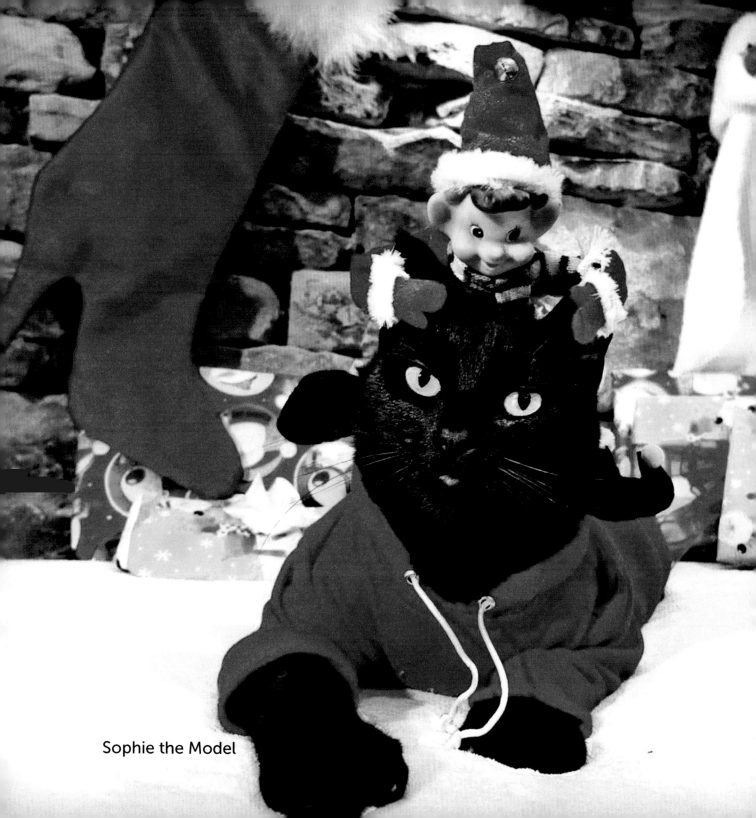

Sophie the Model

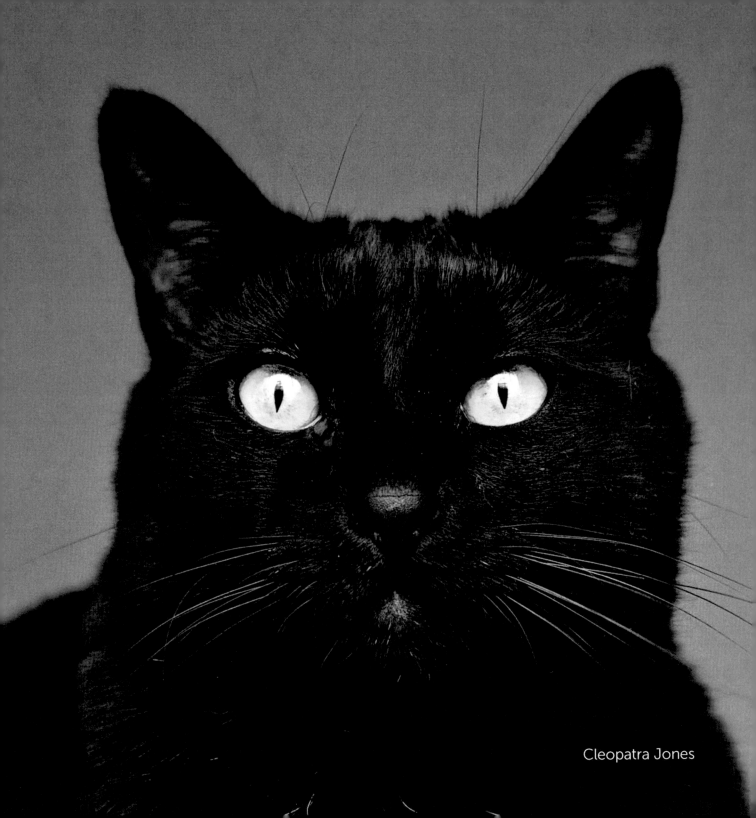

Cleopatra Jones

The Story of Toledo
by Toledo, with R.J. Peters

This is not about cities in Ohio or Spain, or even a company that manufactures scales. It's about me, Toledo the Cat. I don't know where I was born, so it's not about that either. But you soon will see how I got my name.

All I remember is being very small, hungry, alone, and deeply afraid. The dark place where I was hiding was a garage, and the cloth things I had crawled under were oil and grease-soaked "shop rags" with an acrid smell that burned my eyes and nose.

I didn't want to be there, but my mother was gone and I instinctively stayed in hiding, waiting for her to return and take me to a better location. But that never happened.

Instead, as I huddled in this terrifying place, a woman screamed and came after me with a broom. I darted from nook to cranny, and as she caught glimpses of me, she yelled, "It's a rat! Omigod, we have rats!"

When she lost sight of me, she left the garage, muttering about calling the pest control man, whatever that meant. But he must have been too busy or too expensive, because instead, and for free, someone from animal rescue came to this place on Toledo Street. A calm and quiet lady gently lifted the rags off me and whispered, "Oh, poor thing! It's a kitten!" She carefully lifted me up and into something she called a "pet taxi." She asked the woman who had screamed at me if she would like to keep me, now that she knew I was a kitten and not a rat, but the woman snarled, "No way. It's black, and that's bad luck. I have enough of that already. Get it out of here!"

Soon, I found myself in yet another enclosure called a "cage," in a room full of more cages, which in turn were occupied by more cats. I was happy to be out of that garage where the mean woman wanted to

hurt me, but I missed my mother and wondered if she would come for me. But how would she know where to find me now? I cried; no one answered.

Sadly, I never saw her again and will never know what happened to her or my brothers and sisters. In time, however, I was able to relax in my small, but comfortable new home with plenty to eat and lots of people who enjoyed petting and playing with me every afternoon. I enjoyed the attention, and no one ever mistook me for a rat again.

Life at the shelter became routine but bearable, bolstered by hope, as one by one, and sometimes two, the other cats disappeared. There was an air of happiness as they left with new people, so I began to hope for a new person of my own. The word "adopted" came up often, but new kitties kept coming in, too. Many of them were black, like me, and we became friends. There wasn't much time to become friends with the other cats, though, because they didn't stay long. The ones with long hair and pretty stripes or patches of color were heading off to new lives with people who seemed thrilled to have them.

At least, I was never lonely, and it became more fun one day when the cages disappeared. We were all "liberated," so to speak, when my favorite lady, the one who rescued me, said we had become a no-cage, open shelter. It was still controlled, though, and compatible groups were free in their own rooms. That was even better, because now some of us with a lot of energy could wrestle and chase. I was in the "kitten room," clearly the most fun room in the house. A striking Turkish Van cat named Radar took charge of the newest kittens. He and Mom groomed his long white coat with orange patches daily.

And then one day, I went for a ride inside that pet taxi thing again. Oh please, no, don't take me back to that garage! My eyes grew wide, and I trembled and cowered inside the taxi. We didn't go back to the garage, but I was plenty scared where I ended up.

It smelled of disinfectant and strange animal scents. Worse, the

incessant barking of dogs came from nowhere and everywhere, relentlessly assaulting my sensitive ears. A few meows and yowls occasionally broke through the din, and I became worried I'd never see my favorite lady again. What was this place? First I lose my mother, and now I'm afraid I've lost my "other mother," too. So what does a cat do when things get this bad? Well, I just wilted, curled up and pretended to be asleep. Maybe no one would notice me. There wasn't even any food or water in this new place. It was the garage all over again, and I guessed this was the end.

Much to my relief, it wasn't the end, and I soon found myself back at the shelter with all my kitty friends. It took a few days, but I got over the uncomfortable feeling "back there," and the shaved fur eventually grew back under my tail. The other cats had to sniff me pretty thoroughly, and some wrinkled their noses or hissed a little. I returned to normal rather quickly, and we took up where we left off with our games.

In about a year, since I had been there the longest, I became the Keeper of the Catitudes, and it was my chosen responsibility to help newcomers adjust to their new surroundings, especially now that Radar had left. Mom had taken him home with her to be her personal companion and assistant at community events. He was smart and had leadership qualities, which once she recognized precluded his adoption. He had many human admirers and adoption offers, but Mom believed no one but she would really appreciate his intelligence and talent. We all agreed, so it was good to say goodbye to him, knowing he was headed to the utopia of Mom's house and his new schedule of speaking engagements in town.

Radar taught me a lot about kitty behavior and philosophy, and I continued his mission as Master of Orientation, to make life at the shelter comfortable for new arrivals. I wasn't as strict as Radar, who sometimes meted out a swift swat to a new cat for trying to start something. I found I could simply sit by a cat having a melt-down until it crouched and relaxed, closing its eyes. I would sit as near as it would tolerate, sometimes against its trembling body until the shaking

stopped. Shelter life can be very stressful, and not all kitties adapt quickly, or at all.

My favorites were the kittens. They were always up for a game, and at my young age, so was I. I made a lot of kitten friends, and many of them, even the black ones, were adopted if they were young and spunky enough. So I had to learn not to become too attached, just as Mom often said, or I would find my heart broken over and over.

Two friends who didn't get adopted were Stubby and her mother, Tara. Not only were they completely black, but Stubby was the only survivor of a litter of five deformed little ones. Her future looked dim, despite Tara's attentive care, since no one wanted to adopt a black cat, much less, one with disabilities. It took an entire year of emergency trips to the veterinary clinic before we were sure she was going to make it.
Her future is brighter now, and despite stubby legs and a corkscrew tail, she no longer has seizures and can jump and play like any normal cat of 12. Her story appears in one of Mom's books, Our Amazing Cats.

Watching Tara raise Stubby, memories of my own mother faded, but I sometimes felt a little envious of their relationship, which prevented Stubby from becoming as stressed as others who had been separated from their loved ones. And having one kitten left gave Tara purpose in life. Even now, after all these years, those two stay pretty close to each other.

Sadly, some of the older cats could not make the transition to shelter life and suffered a slow decline, and then, despite heroic veterinary interventions, died anyway. If only people realized that cats can pine away just as dogs sometimes do, they might not leave them at shelters so casually or frequently.

Now, as I reflect on my 12 long years here, the things that stand out aren't adventures or upheavals, except for one: having to move due to vandalism and lack of financial support. Just five years after our grand opening, we had to close the shelter and were lucky to find a new place in the country. At the time, a few of the "attractive cats" were adopted, but not one of us black kitties was chosen. Mom said people were prejudiced against black cats, but she would always take care of us.

We're all getting older now, and some from the original group have crossed the Rainbow Bridge, including my fellow black pals Gizmo and Midnight, and later, even Radar. But Stubby and Tara, and a new girl, Mattie, also black, are still with me. And then, this past year, two new kittens showed up, both black, so we know they'll be staying.

Would a blind person know what color we were if no one said anything? Our love would be just as sincere as if we were any other color. Superficial qualities such as color or length of hair are not innate personality traits!

Mom said she hopes she lives long enough to keep taking care of all of us. I'm actually very thankful I did not get adopted. I love Mom so much, I would be devastated to be torn from her. Occasionally, an observant person notices how I look at her. I'm usually just sitting on the floor by her feet, staring up at her face. If she picks me up, I'm in heaven, and I bury my head in the crook of her elbow, kneading her tummy from the framework of her embrace.

I'm not the oldest cat here —Holly has that covered at 27—but I'm still The Keeper of the Catitudes, and I manage the groups that sleep on her bed at night. I decide who stays and who goes. I always stay, of course, because Mom likes the way I knead her tummy. I learned it from Radar: I "prance" with all four paws.

It is my happy dance.

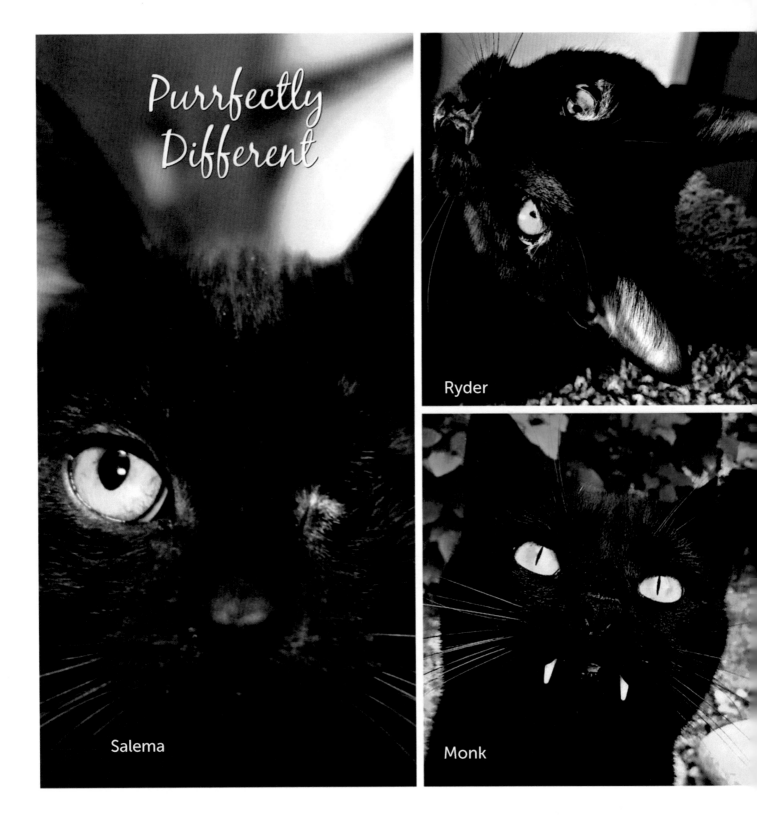

Purrfectly
Different

Salema

Ryder

Monk

Aurora

Nikki

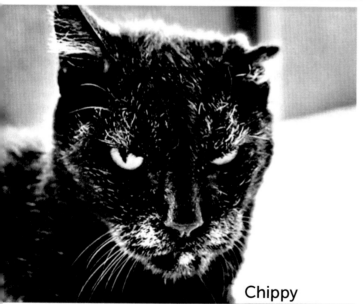

Chippy

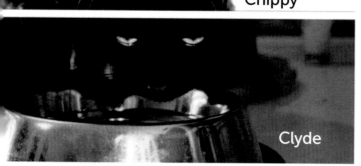

Clyde

Whether born with a congenital condition, suffered an accident, experienced illness or the ravages of time, these cats put the special into special needs. Cross-eyed, one-eyed, three-legged, diabetic, blind, FIV+, geriatric or born this way with eyelidagenesis or polydactyl toes, all are purrfection.

Sophie the Model

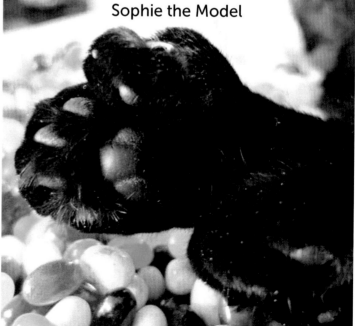

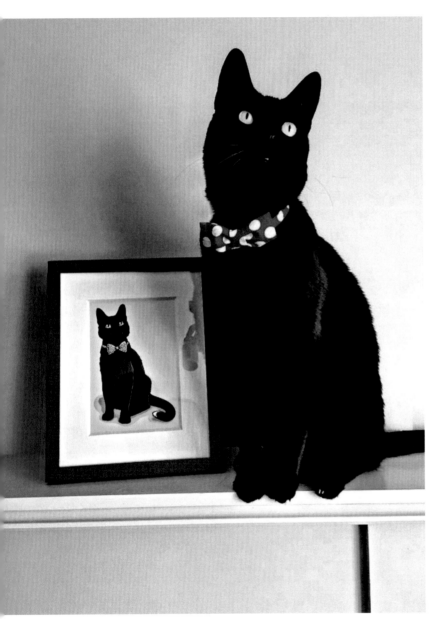

MiLo'S

Kissing

Booth

Milo

U.S., Massachusetts
Nickname: My humans call me Monkey.
Gender: Male.
Breed: Domestic Shorthair.
Birthday: October 31, 2007.
Zodiac sign: I am a Scorpio born in the year of the Pig.

Weight: a lean 11 lbs.
Any unusual or special characteristics: The tip of my tail is white like I dipped it in paint (I didn't!)
Occupation: Full time Food Solicitor, part time Male Meowdel.
Religion: Sun Worshipper.
Interests or hobbies: I love stinky shoes, lounging on important documents, and hunting moths and other insects that enter my domain. I dislike lesser felines and when the humans touch my paws.
Pet Peeves: It is infuriating when the humans ignore my demands for dinner. Crinkly plastic bags freak me out.
Favorite quote:
"Cats are connoisseurs of comfort." - James Herriot
(alternative: "My cat was right about you." - Gail, Bob's Burgers).
What is your idea of purrfect happiness? My idea of purrfect happiness is when my humans get home from work and we all eat chicken and then take a nap together.
What is your favorite food or treat? Chicken tikka masala. Or deli chicken. Or roast chicken. Or Thanksgiving turkey. Last Thanksgiving I stole a whole turkey leg. So I guess I would say poultry is my favorite food.
What is your favorite toy or game? My favorite toy is my spidey (spider) toy. It's actually for flossing my teeth, but I prefer to chase it around the house in the middle of the night.
Why should people adopt black cats? Being a black cat means I coordinate well with any outfit or decor. Black cats are also obviously the handsomest of cats. Just look at me!
If you have any superpower, what would it be? My superpower would be the ability to open cans with my mind. Super Milo would be very overweight from eating all the canned cat food.
Website: Instagram: @mybestiemilo

Confessions of a Feral Black Cat
by Punchy, with Ellen Beck
and Layla Morgan Wilde

My name is Punchy. At least that's what the humans who I choose to reside with call me. It is time for me to write my memoirs. I am an old cat, you see, about 18 years, born a feral with no one around to record my birthdate. They say it's about 90-something in human years. I can feel in my bones that my time grows near, although I have to admit, it has been a heck of a ride. I am now thin and slow, and sunshine, a bit of food and water are my main pleasures. I will also admit to a grudging fondness for the human man who makes bonfires on cool evenings and scratches my ears.

My mother (bless her soul) was feral, my father, well, I can't say for certain, but likely it was Mr. Jeeves, a jet black cat with just a small patch of white. He's long gone, but remains my hero. He was leader of the colony for many years. Not only was he the patriarch, but he'd recruit other cats and bring home abandoned kittens. One of them, Itty, is still alive. Yup, he's inky black, too. He's my friend, but more about him later.

I grew up as a stray in Iowa, doing what I could to survive, There were times along the way when I noticed that some of those upright, non-hairy things called "humans" put out cat food, fresh water and sometimes tasty leftovers from their own meals. I didn't have much use for these hairless creatures, except for their food and water.

As I grew up, my nights became exciting: nights of love, of fights, of being on the prowl. I was a sleek mini panther, full of vigor, full of myself and of course full of love for the ladies. I spent many a night howling both in pleasure and (when a bigger

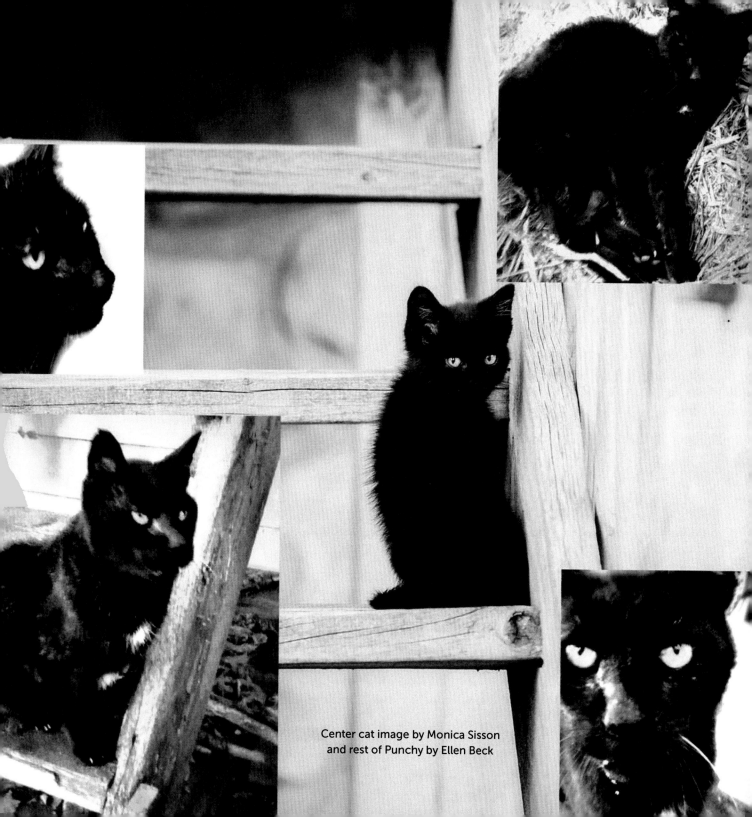

Center cat image by Monica Sisson
and rest of Punchy by Ellen Beck

male was around) yowling in pain. I was a much larger cat in my younger days, you see, but there was always someone bigger.

I remember one fight in particular. It was, of course, over a lady cat: the gals always got me in trouble. She chirred at me, but showed her love to him. When his back was turned, I pounced. There was fur everywhere, he had the paws of a boxer. He got my ear something terrible, along with some deep bites. I just wanted to lie down, and the closest place was the human's house which always had food and water. Taking it easy for a bit sounded good until I recuperated enough to leave again. Even nice humans can't be altogether trusted. Look at all the horrors they've caused black cats! No, I hunkered down out of plain sight, in the shadows of the barn. It's the way of the wild, for better or worse.

Some of the lady loves I had previously known lived there, and surprisingly, there were black cats like me, as well as others. Word of free meals travels fast. This was all fine and dandy: I took the food I wanted, found a spot where I could hide, and stayed away from the other cats, but especially the humans. Before long, my wounds healed and the future looked, if not bright, at least hopeful.

Cats are born survivors, or, some say, opportunists. I stayed around the food and the water, and one day there was a cat trap. Sneaky devils, those humans. Hmmf, I'd seen those contraptions before – this ain't my first rodeo! I had evaded the trap many times, but this particular evening, the ripe scent of sardines proved my nemesis. I thought I could do a quick grab and run but SNAP, the metal jaws trapped me. The fishy treat was no reward. The very next day, off I went to the painful place.

Imagine being free for years and then inside a nightmare called "the vet's office." filled with barking dogs and sharp metal things. At age 8 or 9, I was finally neutered. That could

be a headline: Senior Loses His Balls. Seriously, it was about time. I have no regrets about my very long history with the ladies. Good times. Within a few weeks, I found the ladies less interesting, but I still didn't care for the humans. I would run and hide from them every chance I got. I also noticed that humans had a fondness for this trap, and I would see all sorts of cats go in and then come back smelling funny from the V-E-T. Often, I overheard they had found a forever home, whatever that meant. All a forever home meant to me was one less cat at the food dish.

The years passed by...glorious springs, lovely summers, crisp autumns and cold, hard Iowa winters. I made friends with the colony cats and grew fond of many. I still miss Mr. Jeeves and Lightning, Beaner, GiGi, and oh so many others who went to the Bridge before me. Itty is still with us, but he was very lost after Mr. Jeeves passed, as we all were, because everybody loved Mr. Jeeves. Whenever a cat passed away, the humans cried. Some they had to help cross the Bridge. I hope they miss me when my time comes. That time is inching closer. The humans call it a sharp decline, but I'm still enjoying sunbathing in the garden or hiding in the cool shade under the tall corn and tomato plants. My movements are old-man-slow, conserving my remaining energy for eating and sleeping. This is likely my last summer to feel the earth beneath my paws, and I have no regrets. My life was lived on my terms, and despite my tolerance for humans, I will not abide those soul-stealing cameras. Sorry, dear reader, there are no good pictures of me. I also don't understand where some humans get their notions about black cats being evil or unlucky. I could not feel any luckier.

I will never belong to a human, and although I don't live inside a house, I know what a forever home is, and I know love. The humans have noticed my friendlier demeanor: it's my way of saying my slow goodbyes. It's taken a long time to admit this, but I like (okay, maybe even love) these people and have

decided that after I cross the Bridge, I shall meet them when they arrive. I will again be the mini-panther I was in my youth, and when they bend over to pet me, this black cat will purr.

Punchy

U.S., Iowa
Gender: Male.
Breed: Domestic Shorthair.
Birthday: Unknown. Gotcha Day: Lost in the mists of time @1998.
Zodiac sign: Gemini.
Weight: Who knows, who cares? I'm feral.
Any unusual or special characteristics: Feisty, super survivor.
Occupation: Retired. Former patriarch of a feral colony in Iowa.
Religion: Sun worshipper.
Interests or hobbies: Sunny days, lounging in the garden. Garden snooperviser.
Pet Peeve: Humans I don't know.
Favorite quote: "Goodbyes are only for those who love with their eyes. For those who love with their heart and soul, there is no separation." – Rumi.
Why should people adopt black cats? All cats are special, but black ones are a shade more special.
What is your idea of purrfect happiness? A day filled with warm sunshine.
What is your favorite food or treat? Fish.
What is your favorite toy or game? Ignoring humans.
If you could choose any superpower, what would it be? To live forever.

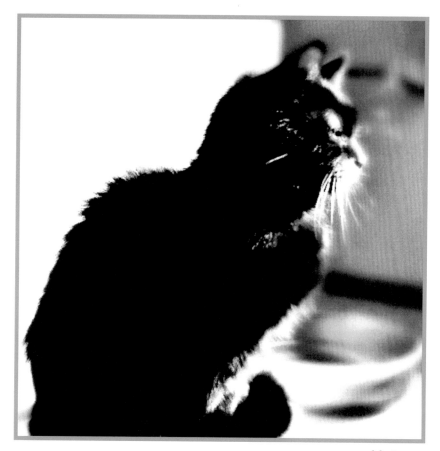

Hetam

Hetam

U.S., Virginia
Name origin: Hetam (means black in Indonesian).
Gender: Male/neutered.
Breed: Domestic Longhair.
Birthday: 6/20/1994 Died: 1/17/2010.
Zodiac sign: Mom says I'm a Gemini.
Weight: 11 lbs.
Any unusual or special characteristics: When they first discovered I was diabetic, I had nasty seizures. The doctor said they damaged me and that I wasn't quite as smart afterwards (balderdash). But I refused to stop and just kept on keeping on.
Occupation: Guard Cat. I took it upon myself to make sure no one came in the house unless I approved. Although, I have to admit, I usually ran away if it was someone or some cat that was scary.
Religion: I am a devoted meow-ist.
Interests or hobbies: I love to groom my daddy's beard. I like feeling macho. I despise fighting dogs – I always try to stop them but when it doesn't work, I bite them & my owner, too, if she's close by – she should stop them first!
Pet Peeves: Dogs who raise kittens. It's all wrong. I was raised by a cat, the way it should be.
Favorite quote: Mom saying, "Such a handsome kitty!"
What is your idea of purrfect happiness? Lying in the sun with my best friend, Billee. Sometimes he grooms me. Wonderful.
What is your favorite food or treat? I like food. Any food. Just give me more!
What is your favorite toy or game? When I was young, I used to like those toys that dangle down, and I could leap and try to catch them. Now I rarely play, it's more fun to nap.
Why should people adopt black cats? Because we're the bestest.

Spooky Times Nine
by Spooky, with Ellen Pilch

Spooky here, not sure if I am on my eighth or ninth life so I thought I should write my memoirs. I sure hope it's my eighth life because I am struggling with kidney disease, and I love this family most of all and don't want to leave just yet. I paid my rent here; I brought them a chipmunk, and Mom says that's payment for 10 years, so I still have almost 7 years of rent paid up in full!

I started my life about a half mile down the road from where I currently reside. Yeah, I'm no globetrotter. Those folks called me Marvin. They were okay, but their sons were kind of loud and there was a lot of drama all the time so I decided to look for greener catnip. Soon, I found a home with a very sweet blonde lady, Heather and her gruff husband. She was always out in the yard playing with her cats. There were four, Kit, Bertie Bee, Boots and I forget the other one's name (that happens to cats and people as they age).

Those cats were all related, Kit was the mom, and those were her babies. I always felt a bit like an outsider, and sometimes they were mean to me. I really liked my human Mom, though, so I stuck around. She always said I was a love. I spent much of my time wandering the neighborhood, making many friends. Whenever anyone saw me in their yard, they would offer me a snack. I was just looking for some attention, but I didn't want to hurt anyone's feelings, so I always scarfed up any snack that I was offered.

Did you know that black cats tend to be very social and outgoing? I am also very adaptable. I can fit in anywhere and am very quick to catch on to patterns. I always remembered

the neighbors' schedules so I could show up when they were getting home from work or outside BBQing dinner. If you keep someone company while they are outside cooking, they will definitely feel obligated to give you something from the grill, especially if you rub up against their ankles with a velvety black tail.

I divided my time between a couple of families who were friendly with my earlier family. They were all cat lovers so they liked to get together for dinner. Every few weeks, Heather the yellow-haired lady would visit the black-haired lady. I would hang out in the yard while they chatted and smoked. Then I would walk Heather home. She taught me that cars were scary. I wasn't supposed to go near the busy road, but there was a lot of good hunting on the other side of the street, so I would get a big running start and practically fly across the street. That probably ate up a couple of my lives, but it was a small price to pay for fresh meat!

I hung out with the black-haired lady and her husband for 5 or 6 years. Then the lady stopped smoking and was often gone all day. I don't know where she went, but it must have been a bad place because she lost her hair and got very thin. Then about nine months later, she was gone and never came back. Her hubby wasn't friendly anymore and so I stayed away. They were never as close to me as Heather, not that I was that close to anyone, and I moved on.

I ended up spending lots of time at the house just beyond the house where I now live. That couple was very nice and even bought me a heated bed for their porch so I could get toasty warm on cold days. They even let me in their house sometimes, but they had two other cats who didn't make me feel welcome there. I did enjoy playing with their toys and would occasionally carry one to the spare bedroom, where I

would nap.

Back then, when I was awake, I couldn't sit still, I had to be outside. One time, a neighbor brought me onto their enclosed porch for the night because it was raining. I tore up the linoleum by the door trying to get out. I still feel a little bad about that. There were lots of good-hearted folks in the neighborhood, but nothing beats a home of your own.

I used to sneak into a certain cellar when the bulkhead was open. I was sort of planning my retirement, and it looked like this would be a nice man cave for me. Cool in the summer, a pellet stove to sleep near in the winter. I used to visit in the garden in summer and hang out with David, the owner, so I figured I might have a nice lap to sit on, too, in the winter.

Now, if we're counting lives, I may have used up one crossing the road. I know I used one life when I got attacked by something. Not sure what it was, a nasty dog or a coyote. The wild thing bit me good, and I got a big infection in my leg. The good thing about a friendly community are helpful friends. My current Mom, Ellen, found me barely moving and called Heather and her husband. They took me to the vet, which was quite traumatic for me. I hate riding in cars ever since the first time, when they removed my manhood, if you know what I mean. I always wonder: what else they are going to swipe from me?

I have been riding in cars way too much lately. I am embarrassed to admit they I usually get an upset tummy and make a smelly mess. The only good part of that is when we arrive at the vet's, they take me right out back to clean me up. Beats the waiting room!

In 2013, I noticed a lot of changes happening at home. Heather's gruffer than usual hubby was bringing in lots of boxes,

which I thought was great – lots of places to hide and play. He started filling them, though, with his stuff and taking them out. Pretty soon there was nothing left in the house and he was gone with Boots (all their other cats had left for the Bridge–they were a lot older than me). Another man, much younger, moved into the house and didn't seem to care for cats, so I decided to move back to the porch where my heated bed was.

That worked out pretty well. They took me to the vet when they saw I was having trouble walking. I have arthritis, happens to the best of us. Other than the vet trip, they were kind to me. After I had spent about a year living mainly outdoors (but sleeping in my heated bed), their house got robbed. I don't know who did it. I saw a strange vehicle and thought a repairman was there, so I took off. After that, they got an alarm system installed. I can see why a burglar wouldn't like it. The alarm had a very high pitched sound that went on and on.

One rainy night when they weren't home, it went off and scared the Bejesus out of me, so I went over to the nice man, David, who remembered me from all my visits to the garden and let me onto their porch again. This time, I didn't try to get out. I wasn't getting any younger and it was time for a real home. He and his wife Ellen were home all the time, and I could go in and out as I pleased. Sweet!

I figured I should thank them and brought a chipmunk over. That's when they said I was officially theirs! Only one small problem: Mom said I couldn't go outside anymore. She is very protective. She makes Grammie babysit if they're not going to be home. She must think we're going to have a party or something. The cats here are much more welcoming than those at my other homes. I actually feel like I'm truly part of the family. After a several lives bouncing from the street to part-time homes, the great outdoors has lost its lustre.

My only complaint is all the trips to the vet. First, I had Lyme disease (yes, cats can get it) and had to get antibiotics. Then I had high blood pressure and needed pills as well as thyroid meds. Let me tell you, getting old stinks. Now I don't take the blood pressure meds, but my folks stick a needle in me every other day and fill me with water. Is that what water torture is? The fancy name is subcutaneous fluids to ease the symptoms of kidney disease. My folks apologize the whole time and say they are helping me, and maybe they are, because I feel a lot better when they're done.

They have also relaxed their rules a little, and I get to go outside with my dad on sunny days. It's always good to sniff around, and while my urge to hunt critters has diminished, I don't mind hunting for good, old wild catnip. Then a nice roll around on the ground. I love how my black fur absorbs the sun and makes me extra warm and relaxed. It's when I reflect on my long and checkered life.

It's funny how everyone used to call me a mooch and think I was visiting just to get snacks. All I ever wanted was love, I am a needy guy. I wish I had spent my entire life here because this place is just what I was looking for. Nine lives just aren't enough for a cat. I wish I had 19, and they could all be lived right here. I have 13 "brothers and sisters," but we all get lots of love whenever we want it. I do have to pose with a hat or costume once in awhile for my Mom, a cat blogger, but I guess that's a small price to pay for happiness. I must admit that I am an excellent model, and, shhh, don't tell anyone: I secretly enjoy posing for photos, especially wearing a hat.

Spooky

U.S., New York
Nickname: Spookster.
Gender: Male.
Breed: Domestic Shorthair.
Birthday: Born: 2000. Gotcha Day: Sept. 2013. Died April 18, 2016.
Zodiac sign: Mom says I'm a Gemini.
Weight: 13 lbs. (before CKD).
Any unusual or special characteristics: Very friendly, loved all humans and
 other cats.
Occupation: Gracious host when indoors, rodent control officer when outdoors.
Religion: Catholic.
Interests or hobbies: Sleeping.
Pet Peeves: People abandoning pets.
Favorite quote: "Treat others as you want to be treated."
What is your idea of purrfect happiness? A warm lap and a full tummy.
What is your favorite food or treat? I like food. Any food. Just give me more!
What would you choose as your superpower? Turning non-cat lovers into
 cat lovers.
Why should people adopt black cats? They are beautiful, and black goes
 with everything.

Every book and every life must have an ending. This book ends with Spooky's profile. Sadly, Spooky passed away during the early stages of creating this book. Rest in peace and fly free, dear Spooky.

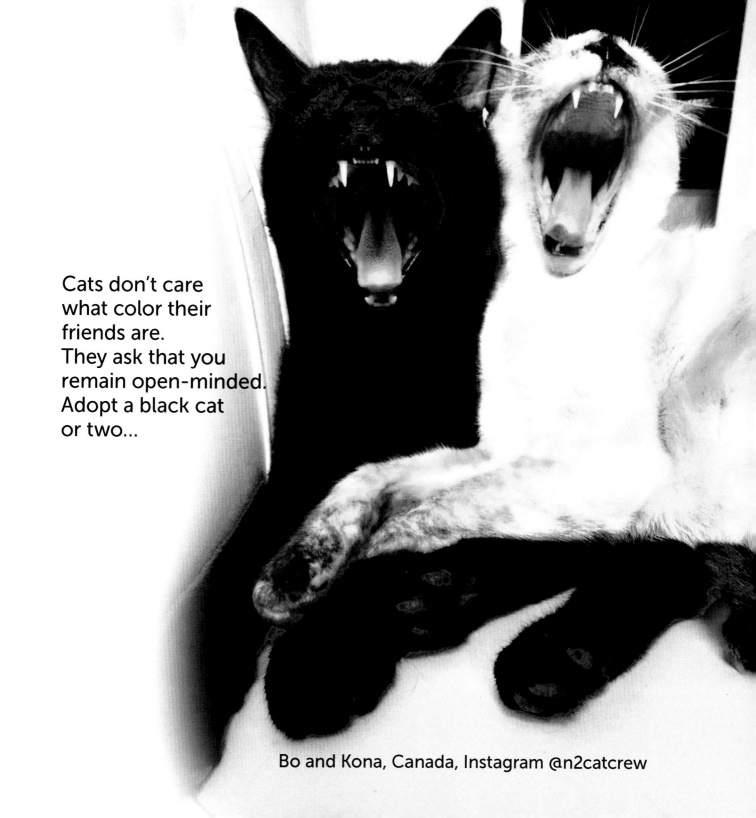

Cats don't care
what color their
friends are.
They ask that you
remain open-minded.
Adopt a black cat
or two...

Bo and Kona, Canada, Instagram @n2catcrew

This project was partially crowdfunded on Kickstarter.
A few upper tier supporters received the perk of being published.
I'm grateful for each and every one of you.

From lower left to right: My name is Bon Ami, that's French for 'good friend' and I'm the best friend to my brothers and a proud mama's boy! My name's Huckleberry and I am sweet and gentle even when my brothers try to wrestle me! Popi is my name and following my mom around is my game!

Kickstarter Backers

Floyd Plymale
Bionic Basil
Catherine Brown
Jennifer Markley
Mark Watson
Gina
Sherman Amsel
Becky Joyner
Cam Collins
Lesley Wilmoth
Winnie
Chris Van Oort
Gail Rivard
Da Tabbies O Trout Towne
Christina Riddle
James Rodgers
Andrea Murphy
Heidi Foster
Tracey Williams
Michelle Kennedy
Bonnie
Dawn Veee
Janine Martinez
Bev Green
Angel Robinson
Karen Alcorn
Jane Dungate
Jacqueline Yeung
Jen Fisher
D. Spiegel
Suzanne Mcmichael
Ginger Crosd
Marjorie Dawson
Claire Blake
Suzanne Doute
Bruce Crocker
Sorcha Bray
Valerie Jeglum
Xi He
Emilia Kay
Darci Peterson
Nicole DuPuis
Kristin Avery
SB.
Tammy Pilgrim
Lynn Kear-Noe
Elizabeth Buttermore

Gretchen Trout
Frances
Diane McLain-Skillicorn
Sean Bowie
chrisinpm
Duncan Berges
Kathie Egan
Cat WIlson
Julia Benson-Slaughter
Clara Neu
Stacy Avila
Jennifer Halbert
Ellen Pilch
Victoria Shotwell
Dan Sibo
Mona Evans
Katie
Stephanie Ann
Michelle Mauro
Steven Fischler
Dessa Williams
Valerie Heimerich
Denise Close
Carolyn Andre
The Swiss Cats
David Schumacher
Kathy Thompson
Gayle Keresey
Cynthia Long-Franks
Debbie Adatto
Erick Villano
Jean-Luc Reyes
Barbara Stuber
Arlenemusume
Jennifer 'Bidlingmeyer' Osterman
Jean-Paul Baldwin
Amber
Lauren Villa-Kelemen
Sean Cox
Nicole Cilimba
Sonja
Kathy Imhauser-Wilkes
Maggie Swanson
Beth P. Emmons
Bethany Meissner
Sarah Young
Kevin Hattori

John Metcalfe
Jacinda Melendez-Klettke
jstenzel
D
Hoodie Hugger
Pamela Allen
T-Rose
Catherine Heckel
Marie Verderame
Vallie Szymanski
Dawn White
B Buttermore
Alexis Morris
Jonas Westerberg
Rachel
Usanee Thamtrakuldee
Kim Poludnianyk
Erika
Christina Marie Tabbee
Suzanne Paterno
Alexa
DeputyDawg
LaGattara Cat Cafe-Melissa Pruitt
Nancy Degenkolb
RJ Peters
Melissa Lapierre
Logocop
drayindallas
Linda
Susan Willett
Erin Connors
twonkykitty
Emily F.
Claire booth
Sally Swanson
Cary Hillman
Alana Grubba
Charles Sucher
Helen Vache
Suz Hinton
Cara Rafanelli
Kelly Felsted
Cynthia Southern
Roxanne Mosier
Ellen Power
Tasha Turner Lennhoff
Lynda Reid

Leopold

Acknowledgements

First, purrs of thanks and gratitude to the 100+ cat contributors and their human owner/editor/assistants. This book could not exist without you.

The project mushroomed beyond the original vision in size, form and timeline. I'm forever grateful for the two designers who book-ended the design. At the beginning, book designer, Michael Rohani designed the initial cover and layout. He stuck with me through the ups and down of the project with kindness and unflagging enthusiasm.

When I hit a rough patch and thought all was lost, Jennifer Markley, one of the book's contributors and wunderkind designer, came to the rescue. She tweaked the cover design, completed and re-laid out the interior design, acting as midwife/guardian angel to bring the overdue book baby to life. Thank you, thank you, thank you!

I'm grateful for the steely grace of Catherine Hiller—an editor's editor who whipped the non-writer's stories and profiles into cohesive shape. Thank you to the generous creative talent, Katie Ruby Miller, for designing all the Black Cats Tell All logos.

To my fellow cat writer/blogger friends, thanks for joining me in celebrating all things cat. Special mention for my dear friend and writing mentor, Darlene Arden, who sadly died before we published.

To the Kickstarter and other backers for your support, patience, and faith in this project.

To my blog readers, friends both real and virtual who shared my content, left comments and DMs of encouragement—they've saved my life more than once.

Thank you to my tiny inner circle who appreciate marathon phone calls about nothing and everything.

To my amazing @blackcatsofIG black cat community on Instagram—your devotion to cats and your caring camaraderie has restored my faith in humanity.

To my parents for instilling my life-long love of reading and kitties—at age three.

To my own cat muses—Clyde, Domino, Odin, Nou Nou and Angel Merlin—for guiding, inspiring and creating everyday magic.

And, to my dear husband, Joe, for loving cats as much as I do. Thanks for doing the heavy lifting during the project—including cleaning our litter boxes.

Author Credits

Cole pg. 9-15; Jessica Josephs @coleandmarmalade
Antonio pg. 21-22; Jennifer M. Markley, @antonioandfrankie
Merlin pg. 23; Cam Collins, @cammycat
Notchik pg. 24-25; Sergey Taran & Layla Morgan Wilde, @Seregraff
Kuro & Django, pg. 26-28; Micha Lema, www.smashgraphics.be
Prince Buddha, pg. 29-35; Chase Holiday, @furballfables
Wingnut, pg. 36-38; Gina Cook, @wingnutcook
Dillinger, pg. 42-45; Jon Glascoe, @the_fulton_zoo
Yin and Yang pg. 61-65; Alasandra Alawine, @www.atcad.blogspot.com
Nala pg. 69-70; Chris Van Oort and Michelle Kelly
Momo & Nova pg. 71-74; Kayla Erickson, @mini.house.panthers
Panther pg. 75-76; Erin Jarvie, @panther_the_black_cat
Luis, pg. 78; Cathy Lund DVM, www.cirt-kitty.com
Zena, pg. 79-80; Jessica Mantifel, @Zena_and_Shera
Penelope Kitten pg. 81-82; Cynthia Mance, @marcyverymuch
Sophie the Model pg. 83-86; Jennifer Miller, @sophie_the_model.
Parsley pg. 87-88; Cathrine Garnel, @BionicBasil
Cleo pg. 91-92; Bev Green, @fozziemum
Blade & Nitro pg. 94-95; Claire Blake, @blade_the_black_cat
Merlin the Exotic pg. 96-97; Katrina White, @merlin_the_exotic
Willow pg. 98-104; Richard East, @vancatmeow
Dexter pg. 107-108; Marie Verderame
Lola pg. 109-114; Floyd Plymale & Layla Morgan Wilde,
 https://www.facebook.com/Lola-632836356735776/
Echo pg. 121-122; Wendie Simonson @four_spoiled_brothers
Ernie pg. 123-124; Suzanne Doute, @theislandcats
Smoky pg. 126; Maureen Calloway Carnevale,
 www.Facebook.com/smoky.blackCatsRule
Rosie pg. 129-133; Kristin Avery, www.thedailypip.com
Shalom pg. 136-144; Chris Hudson, Shelly Hall, @crazycatladyceramics
Clyde pg. 145-149; Layla Morgan Wild, @catwisdom101
Black Cat Club pg. 149; Kat McCann
Toledo pg. 158-162; R.J. Peters, www.ouramazingcats.com
Milo pg. 165-166; Anna Catania, @mybestiemilo
Punchy pg. 167-171; Ellen Beck, Twitter @tannawings &
 Layla Morgan Wilde, @catwisdom101
Hetam pg. 172-173; Diane McLain-Skillicorn
Spooky pg. 174-179; Ellen Pilch, www.15andmeowing.com

Photo Credits

Photo Credits

Blade & Nitro–pg. 77, 94-95, Claire Blake,
 @blade_the_black_cat
Bo–pg. 77, VersaBC, @n2catcrew
Scruffy–pg. 77, Leon and Winnie Sung
Luis–pg. 78, Cathy Lund DVM, www.cirt-kitty.com
Zena–pg. 79-8, Erica Danger, @Ericalikescats
Penelope Kitten–pg. 81-82, Cynthia Mance
 @marcyverymuch
Parsley–pg. 87-88, Cathrine Garnell, @BionicBasil
Ledges–pg. 89-90, 106, 118, 152, Kerry Litzka,
 @BlackCatTrails
Cleo–pg. 91-92, Bev Green, @fozziemum
Horst–pg. 93, Susann Himmel, @Horst_the_Hero
Willow–pg. 98-104, Richard East, @vancatmeow
Dexter–pg. 107-108, Marie Verderame
Lola–pg. 110-114, Floyd Plymale,
 https://www.facebook.com/Lola-
 632836356735776/
Raina–pg. 115, Melissa Barrnett, @black.cat.mafia
Toothless–pg. 116, Ruby Torrero,
 @toothlesstheblack.cat
Blue–pg. 115, Gabriella Molloy
 @grace_in_the_mundane
Cooper–pg. 115, Annex Cat Rescue, @annexcatrescue
Milo–pg. 117, 125, 165-166, Anna Catania
 @mybestiemilo
AC–pg. 117, 134, Kate Funk, @thekatefunk
Fields–pg. 117, Gracious Lim
Papa–pg. 118, Geri Gongora, @gerigongora
Echo–pg. 121-122, Wendie Simonson,
 @four_spoiled_brothers
Ernie–pg. 123-124, Suzanne Doute, @theislandcats
Smoky–pg. 126, Maureen Calloway Carnevale,
 www.Facebook.com/smoky.blackCatsRule
Rosie–pg. 129-133, Kristin Avery,
 www.thedailypip.com
Wilmoth–pg. 134, Lesley Wilmoth
Alice–pg. 134-135, Chris Watert, @alice_sees_you
Marvin–pg. 135, Lizzie McLean @minnieandmarvin
Gage–pg. 135, Jean Neil with the late Cliff Murphy

Blade the Black Cat–pg. 135, Claire Blake,
 @Blade_the_black_cat
Shalom–pg. 136-144, Chris Hudson,
 @crazycatladyceramics
Mr. Huu–pg. 150, Pike Kokkoken, @pikeart
Mojeaux–pg. 151, Kat McCann
Ledges, Lenroot, Mayes–pg. 154, Kerry Litzka
 @BlackCatTrails
Yeezy–pg. 155, Brandi Scott, @yeezycat
Cleopatra Jones–pg. 157, Catherine Brown
Toledo–pg. 160-162, R.J. Peters,
 www.ouramazingcats.com
Salema–pg. 163, Risa Rosenthal @anjelliclecats
Ryder–pg. 163, Laura Mason, @rydernoeyelids
Monk–pg. 163, Nicole D.Rienzie, @monkandbean
Aurora–pg. 164, Chase Holiday, @vftafoundation
Nikki–pg. 164, Ronja Hebenstreit, @nikiii_s_welt
Chippy–pg. 164, Kimberly Fox, @ninamydarling
Punchy–pg. 168, 171, Ellen Beck, Twitter @tannawings
Hetam–pg. 172-173, Diane McLain-Skillicorn
Spooky–pg. 174, 177, Ellen Pilch,
 www.15andmeowing.com
Bo & Kona–pg. 180, VersaBC, @n2catcrew
Bon Ami, Huckleberry, Popi–pg. 181, Beckie Joyner
The Shadow 3 (drawing)–pg. 188, Diane Irvine Armitage,
 @pandorasparlour

Author Info

You can reach the author, Layla Morgan Wilde, through the following points of contact:

Cat Wisdom 101
www.catwisdom101.com
Instagram, Facebook & Twitter @catwisdom101
email: info@catwisdom101.com

Connect with our black cat community:
Instagram @blackcatsofIG
Facebook @BlackCATSTellAll

Layla Morgan Wilde, a holistic cat expert and pet industry consultant, is an award-winning journalist and photographer. She is a member of the Cat Writers' Association and in 2011, founded the popular blog, Cat Wisdom 101. She launched the non-profit initiative Black Cats Tell All in 2016 to promote black cat adoption.

A tireless advocate for less adoptable cats since founding the nonprofit Annex Cat Rescue in 1997, she has a soft spot for special needs, senior and black cats. Layla lives in Westchester County, NY with her husband and four special needs feline familiars.

Made in the USA
Middletown, DE
04 December 2018